ShadowHome
PHOTOGRAPHS BY BASTIENNE SCHMIDT

SchattenHeimat
PHOTOGRAPHIEN VON BASTIENNE SCHMIDT

Bastienne Schmidt

jovis

Bastienne Schmidt was born in Munich and spent her childhood in Greece. She studied painting in Italy and lives as a photographer with her family in New York. "ShadowHome" is her third book, she has previously published "Vivir la Muerte" and "American Dreams".

Bastienne Schmidt, geboren in München, verbrachte ihre Kindheit in Griechenland. Sie studierte Malerei in Italien und lebt als freie Photographin mit ihrer Familie in New York. „SchattenHeimat" ist nach „Vivir la Muerte" und „American Dreams" ihr drittes Buch.

© 2004 by jovis Verlag GmbH

Texts by kind permission of the authors.
Pictures by kind permission of the photographer.

All rights reserved.

Translation: Ian Cowley
Design and setting: John and Orna Designs, London
Lithography, printing and binding:
GCC Grafisches Centrum Cuno, Calbe

Bibliographic information published by Die Deutsche Bibliothek
Die Deutsche Bibliothek lists this publication in the Deutsche Nationalbibliographie; detailed bibliographic data are available in the Internet at http://dnb.ddb.de.

jovis Verlag GmbH
Kurfürstenstr. 15/16
10785 Berlin

© 2004 by jovis Verlag GmbH

Das Copyright für die Texte liegt bei den Autoren.
Das Copyright für die Abbildungen liegt bei der Photographin.

Alle Rechte vorbehalten.

Übersetzung: Ian Cowley
Gestaltung und Satz: John and Orna Designs, London
Lithographie, Druck und Bindung:
GCC Grafisches Centrum Cuno, Calbe

Bibliographische Information Der Deutschen Bibliothek
Die Deutsche Bibliothek verzeichnet diese Publikation in der Deutschen Nationalbibliographie; detaillierte bibliographische Daten sind im Internet über http://dnb.ddb.de abrufbar.

Tel: +49 (0)30/26 36 72 0
www.jovis.de
ISBN 3-936314-51-9

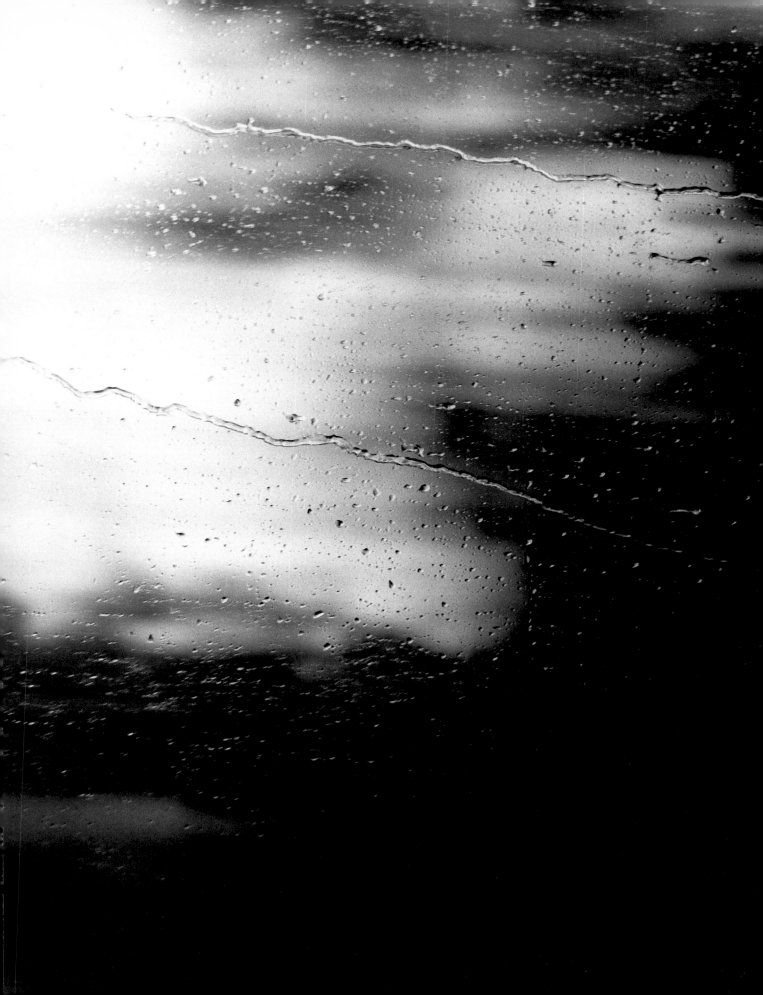

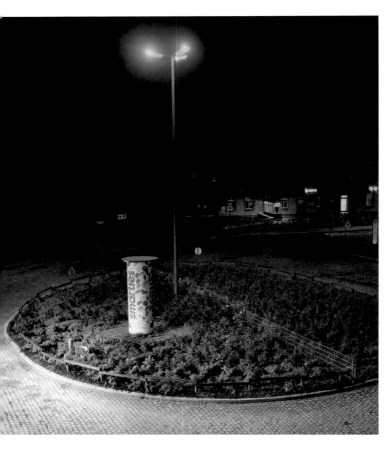 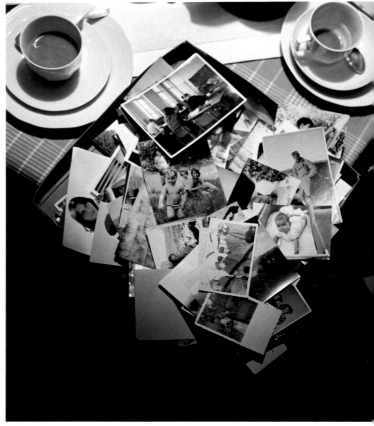

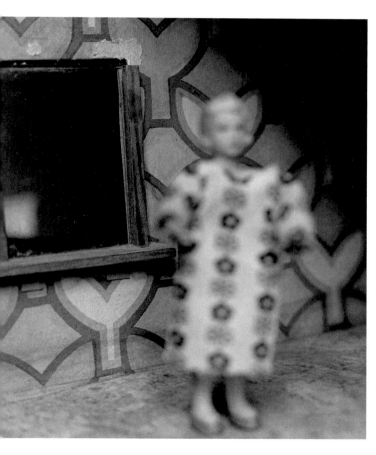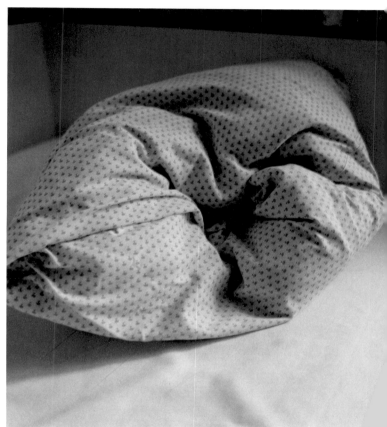

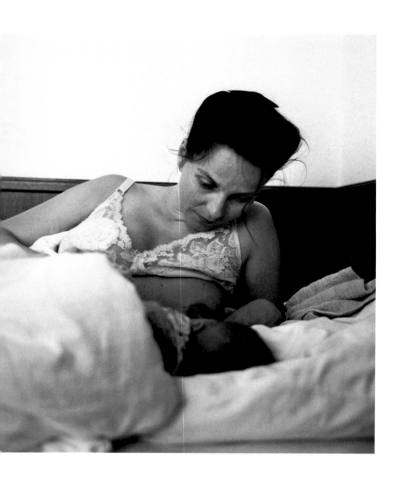

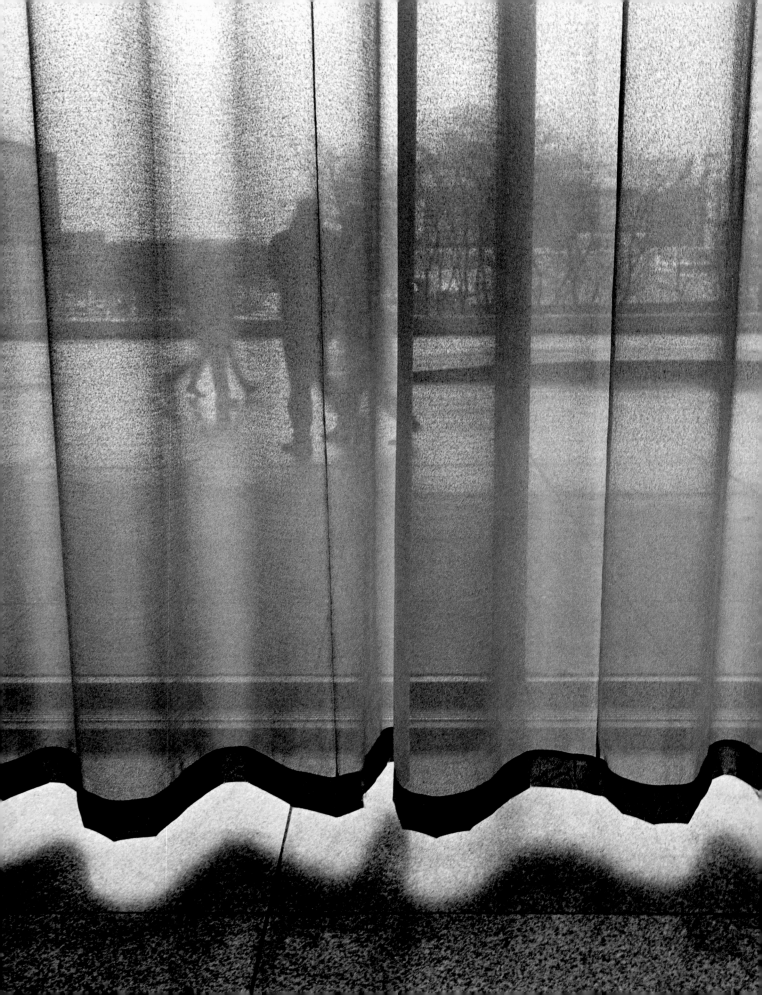

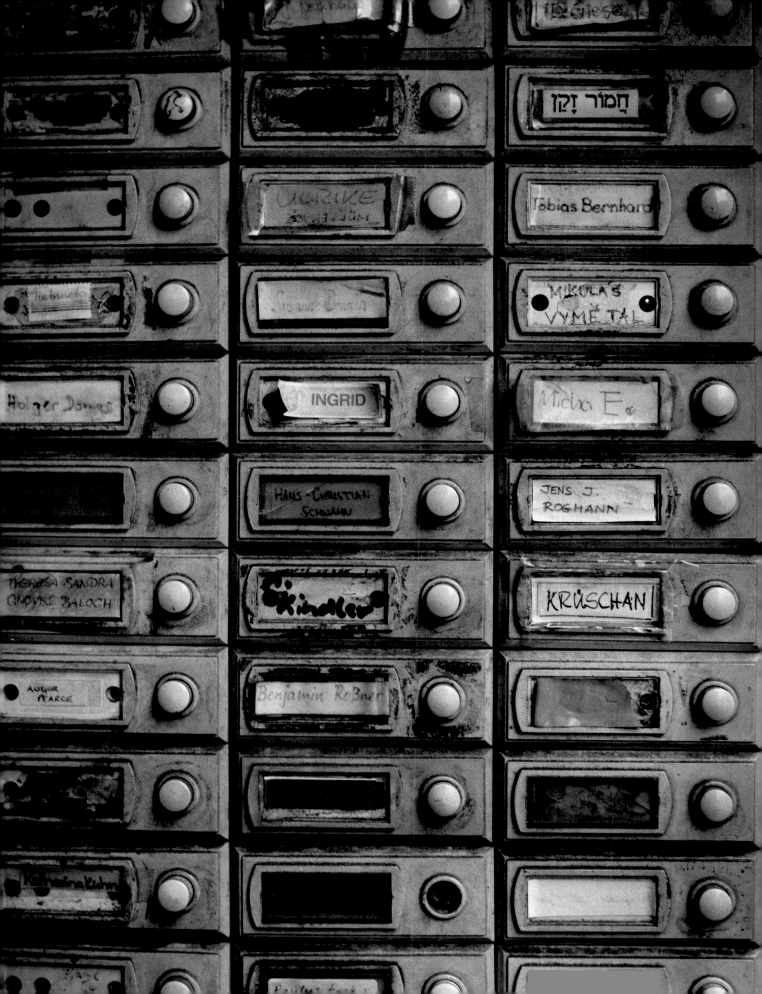

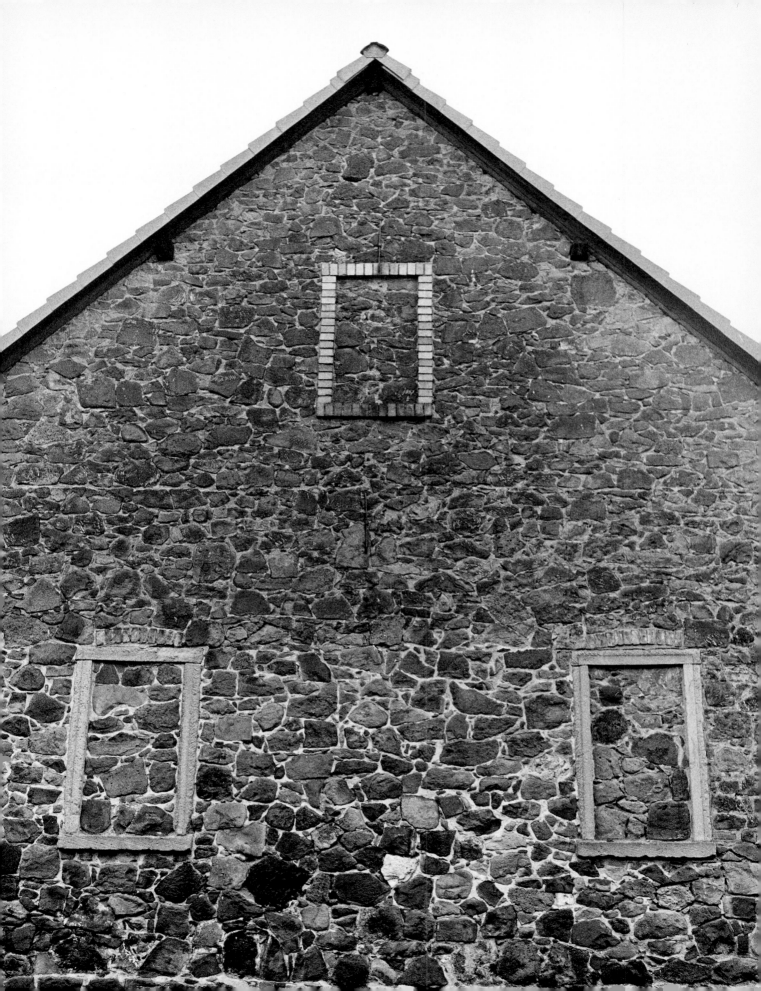

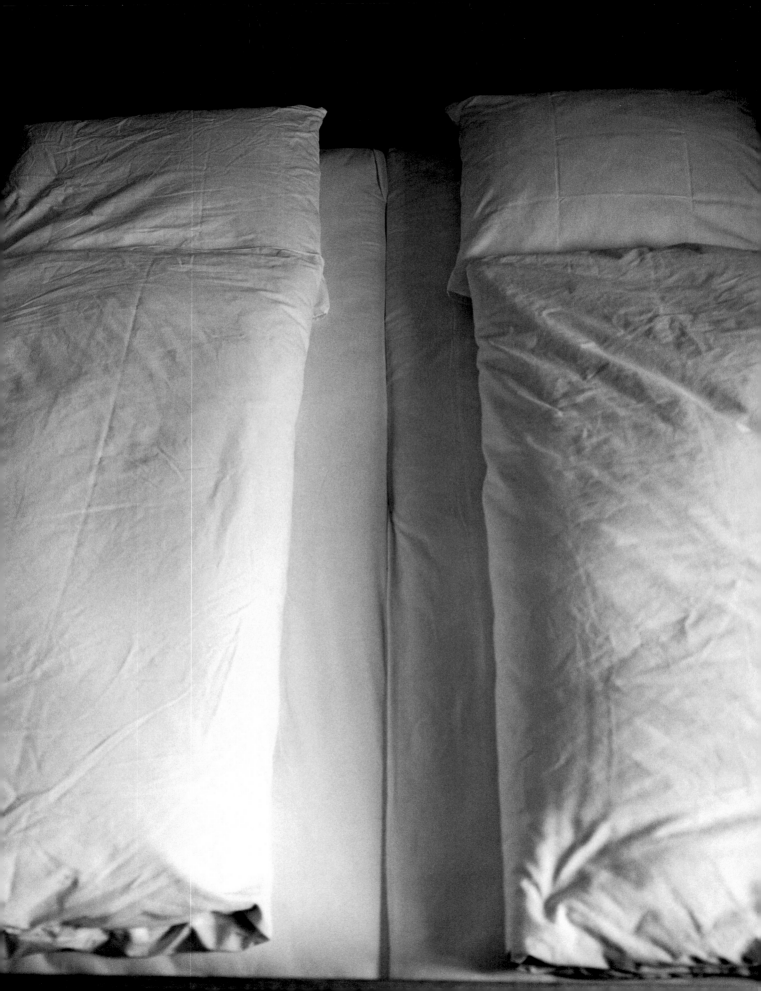

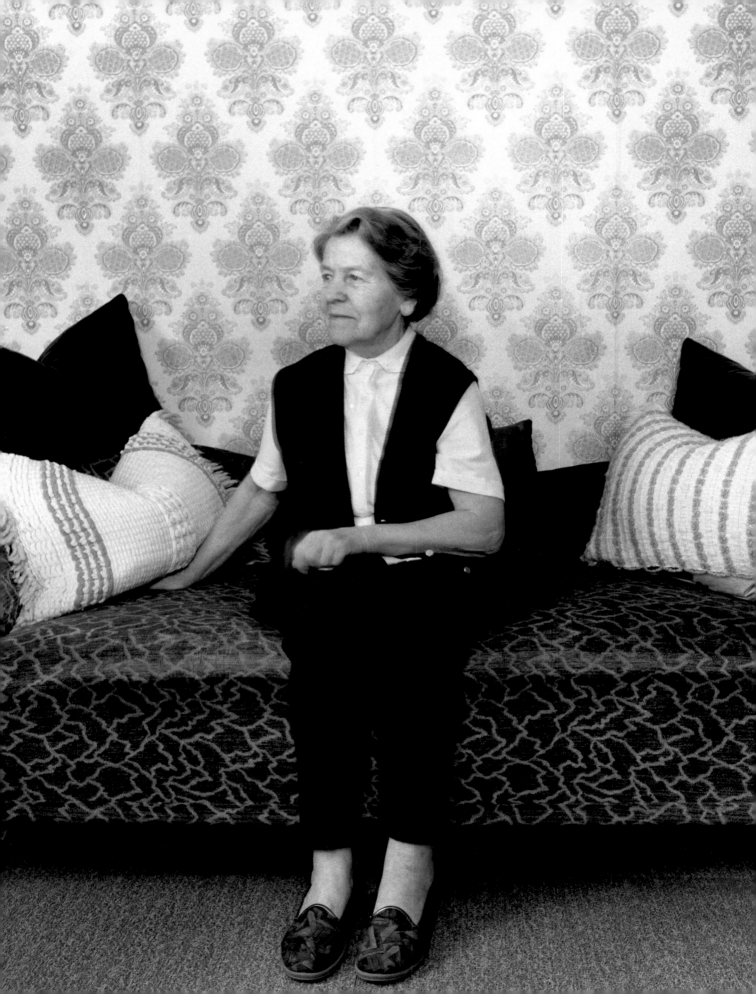

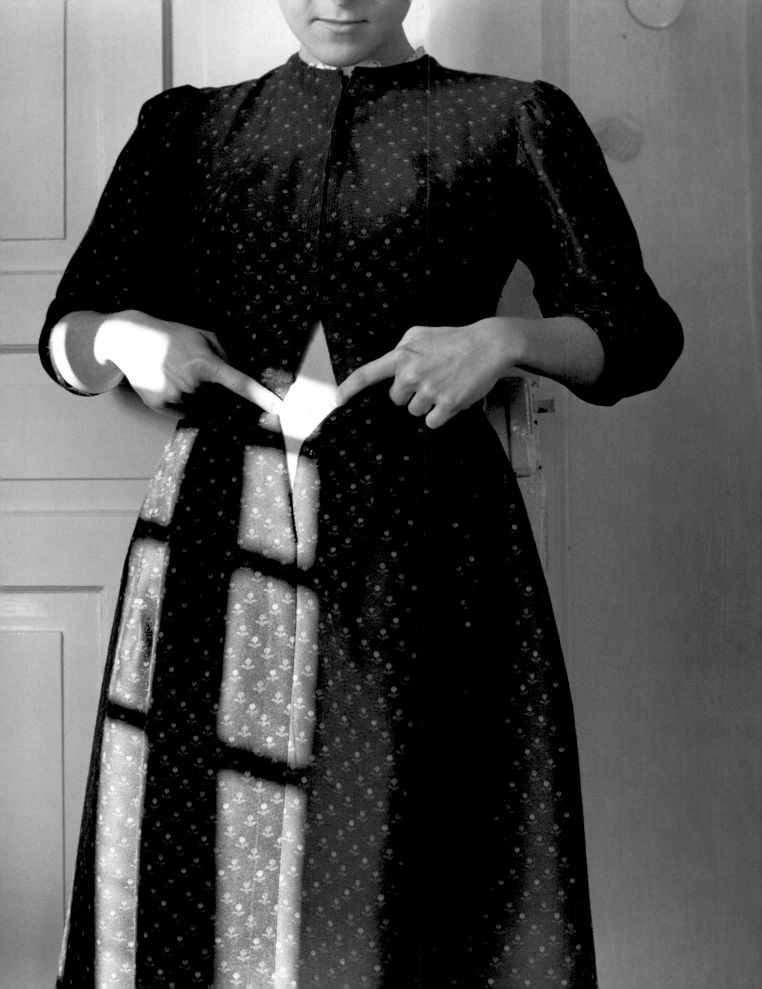

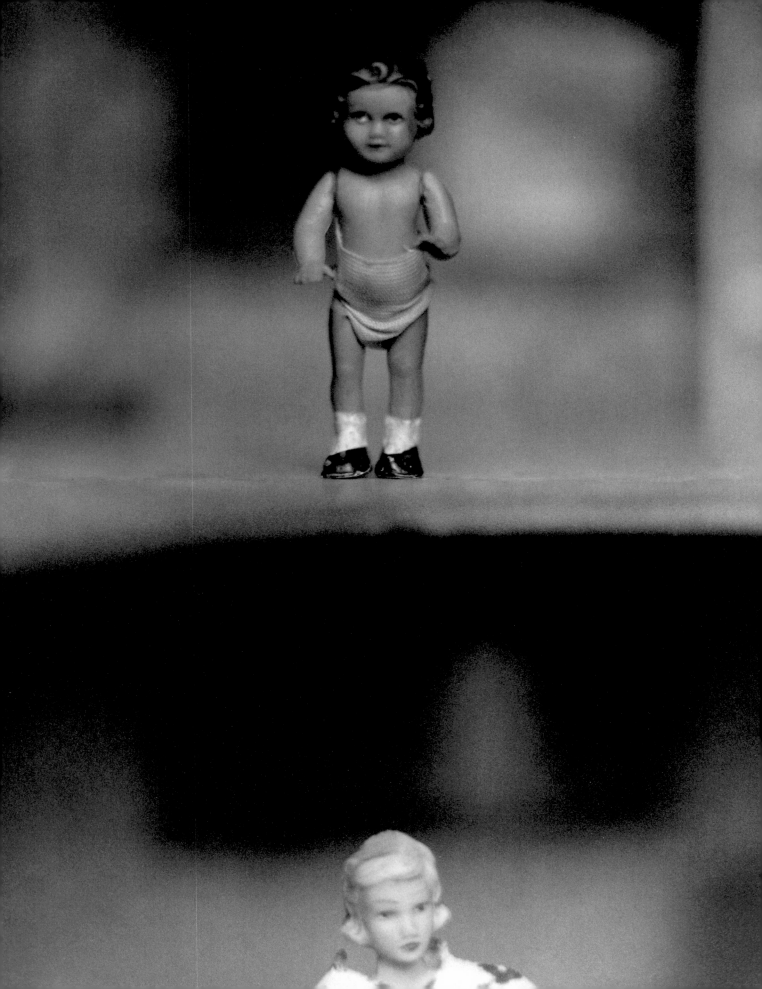

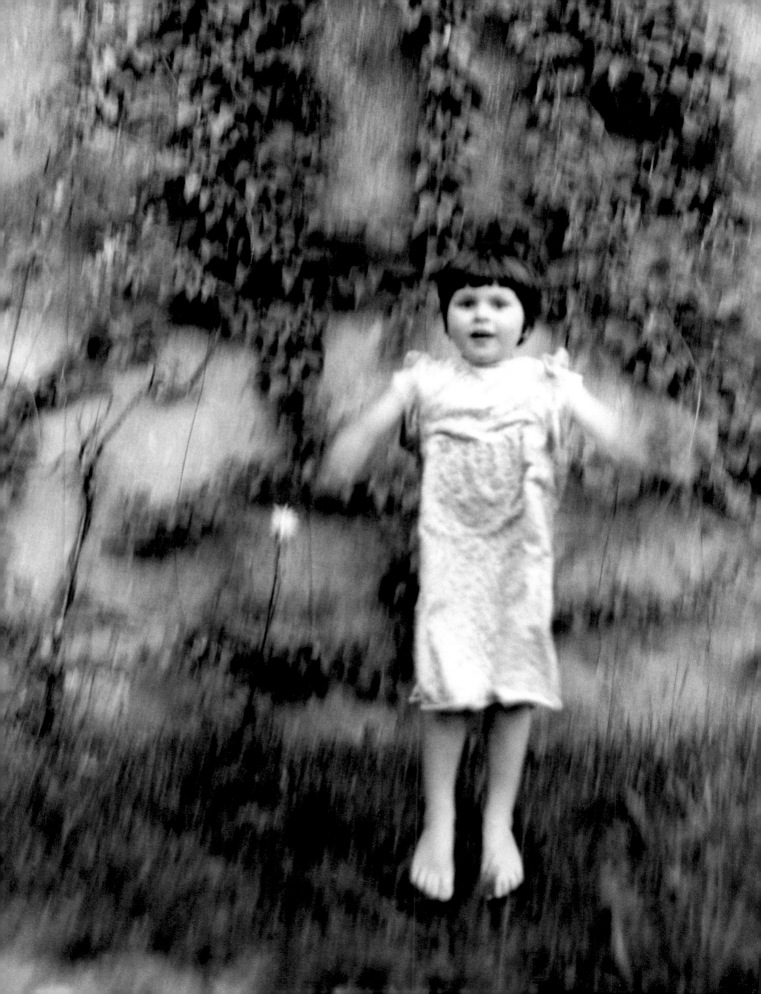

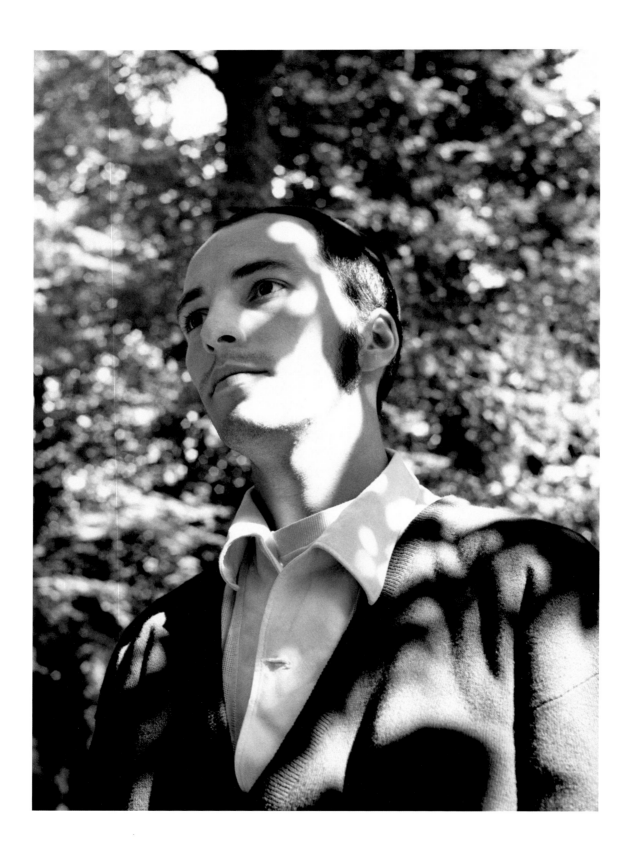

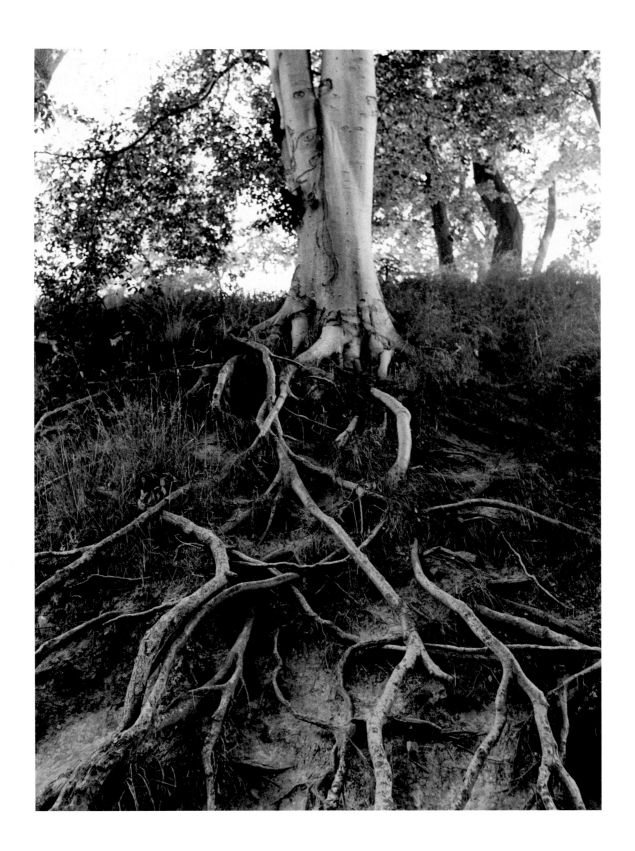

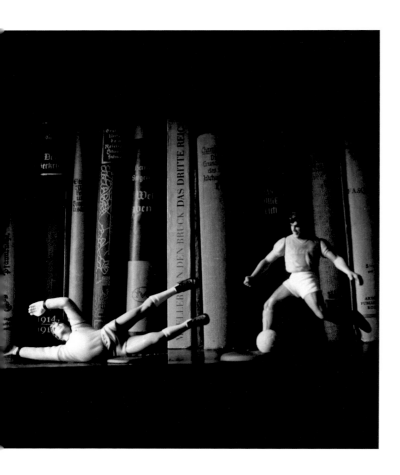

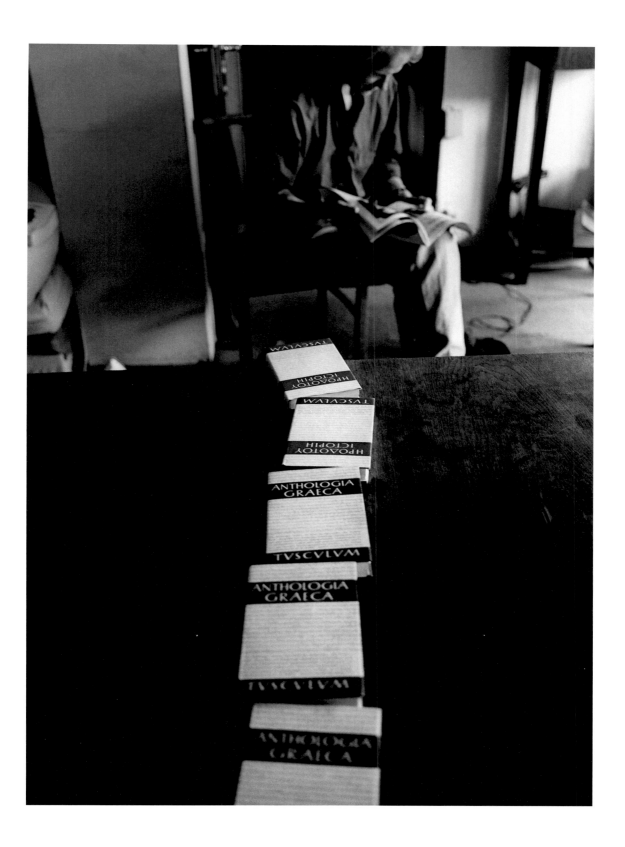

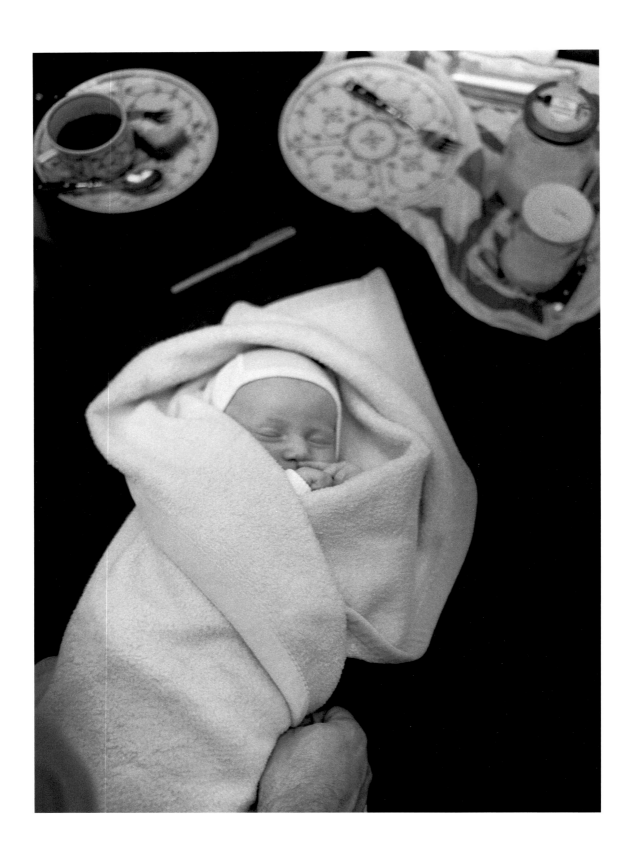

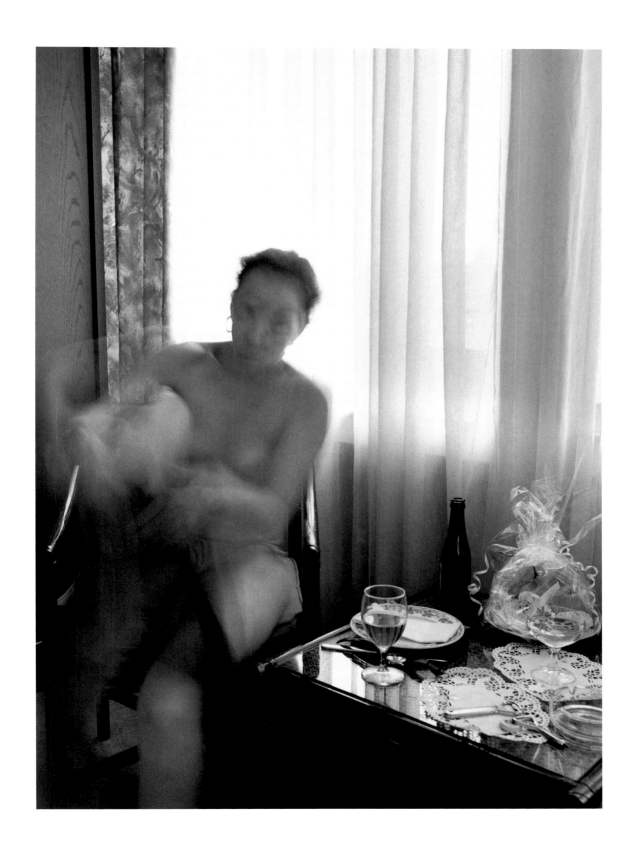

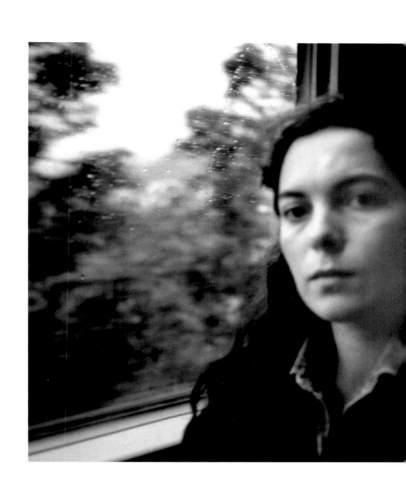

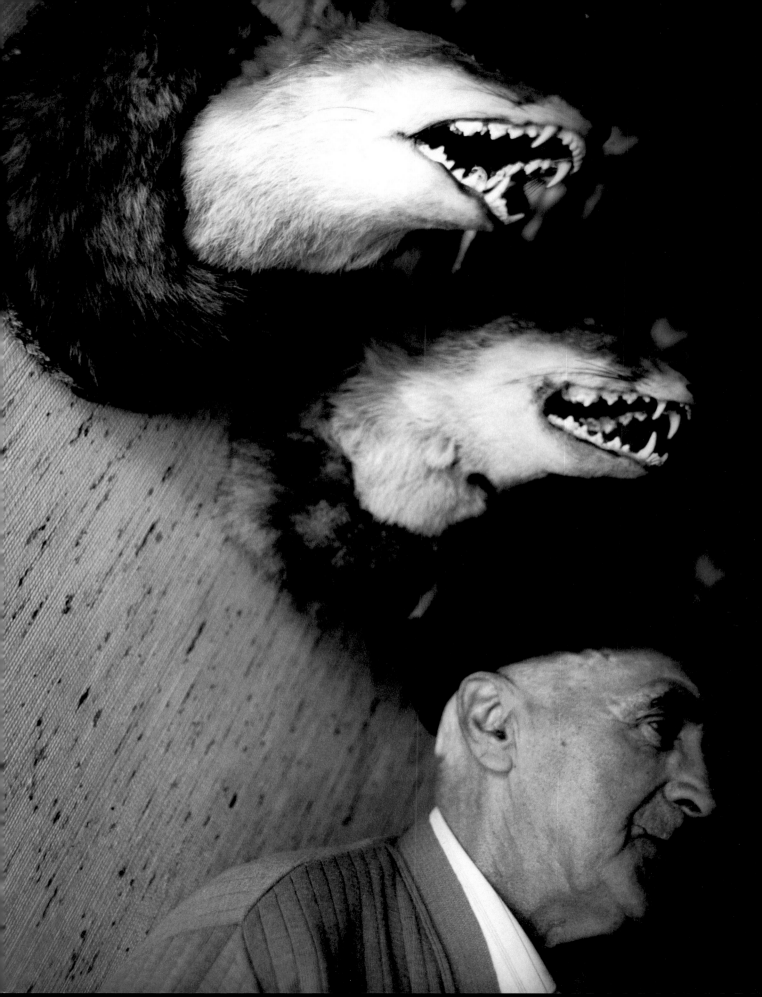

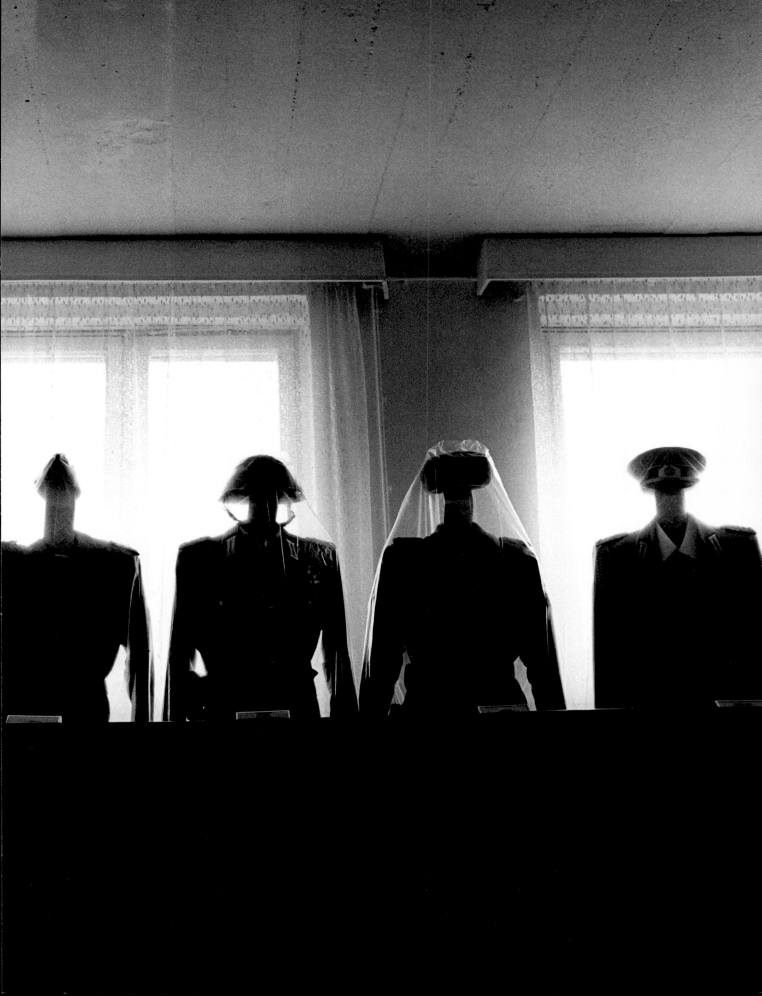

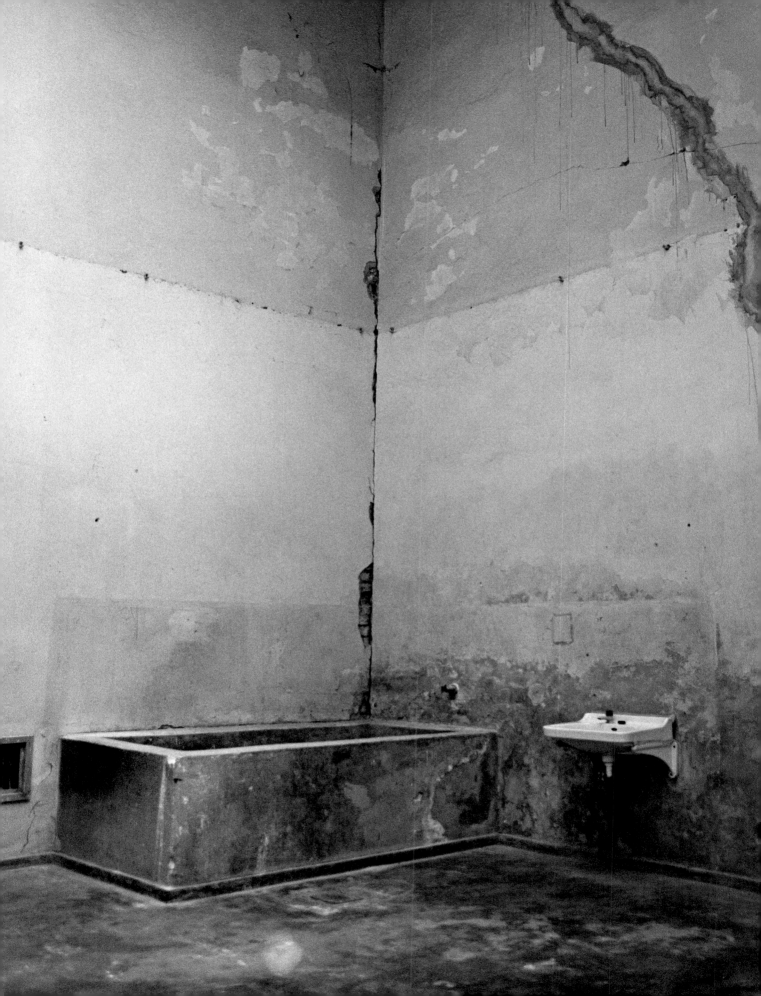

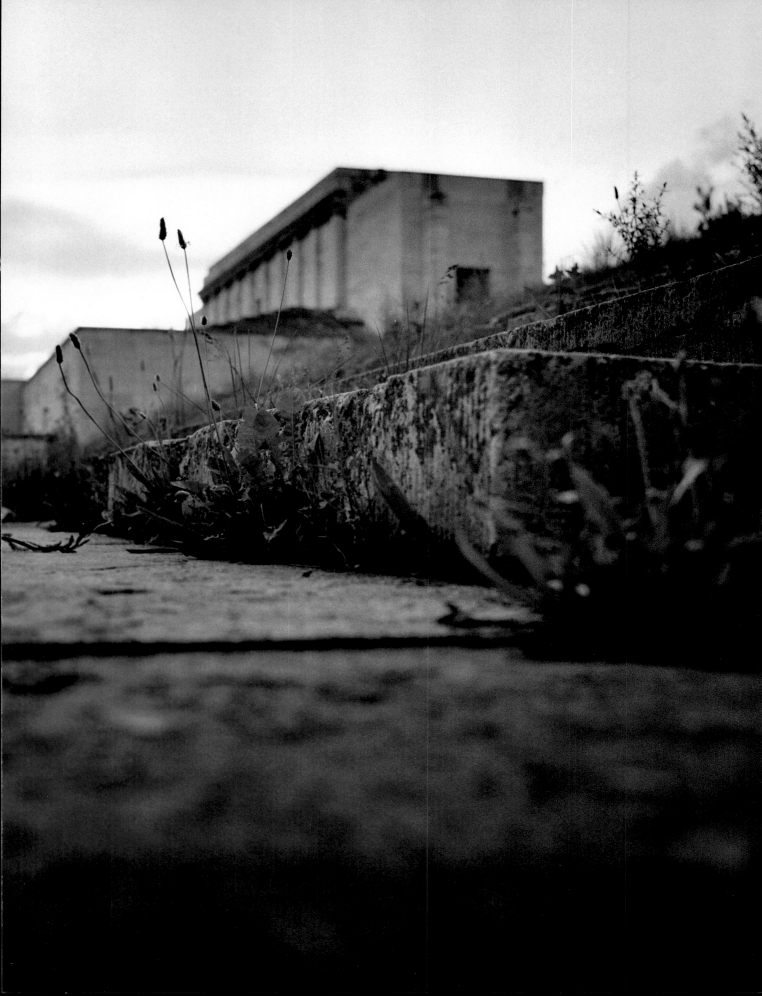

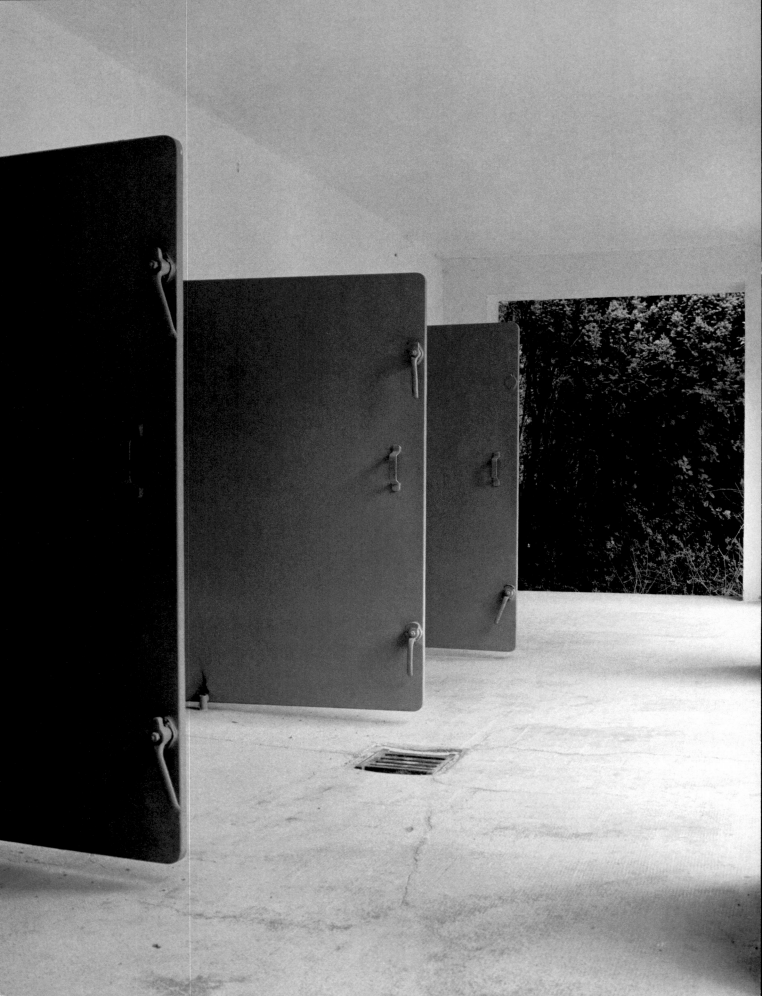

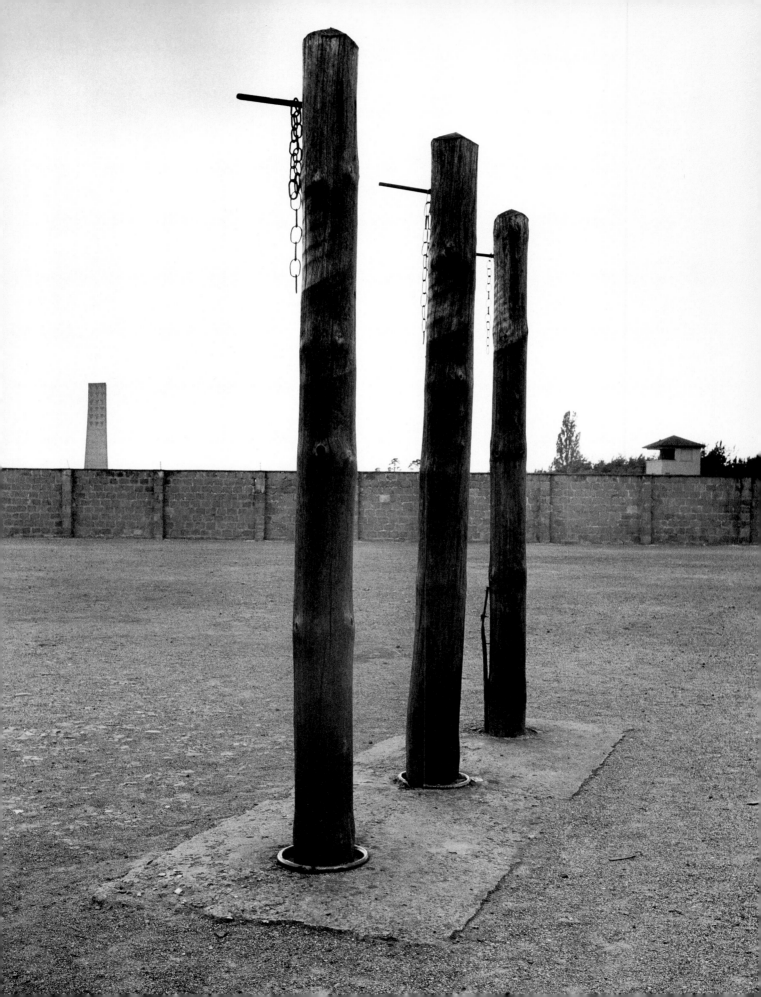

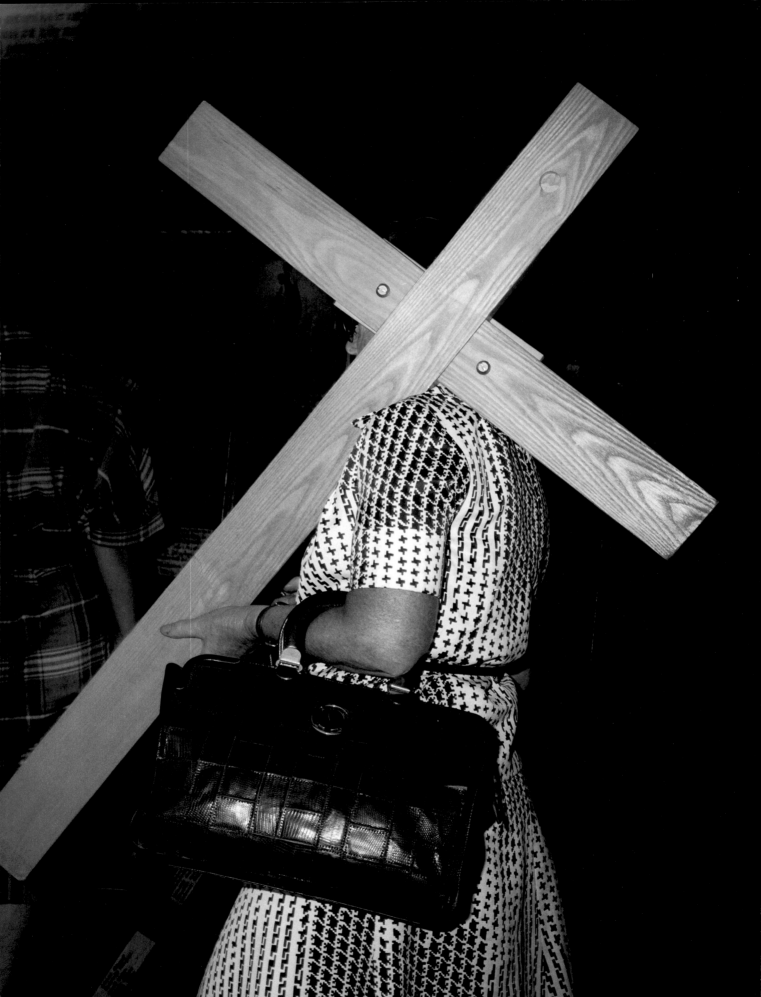

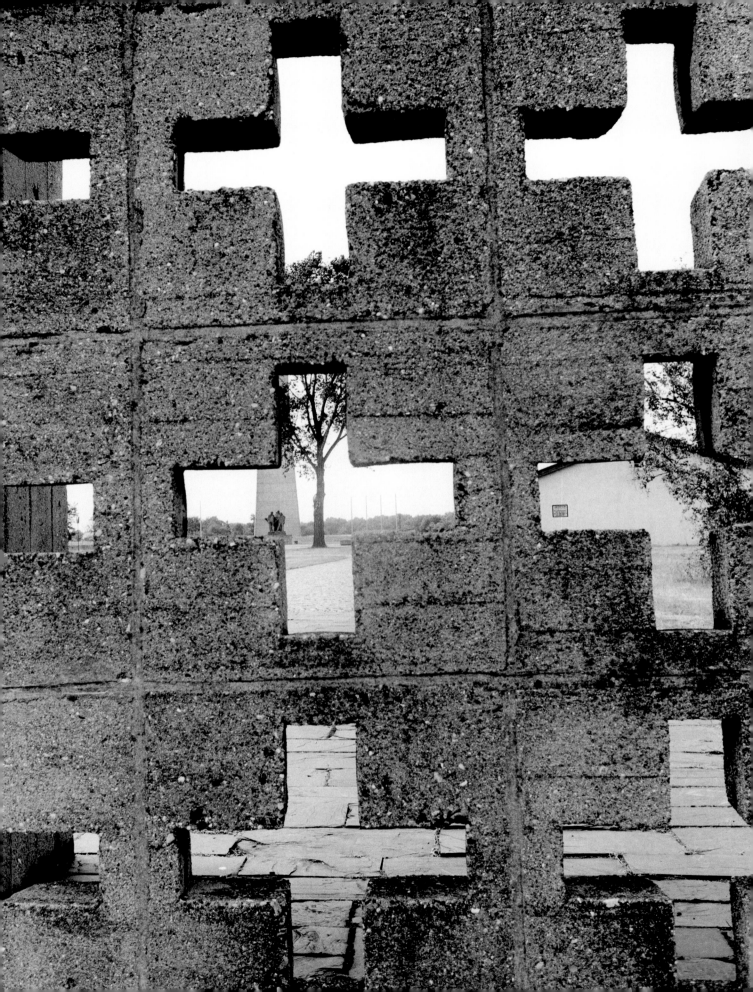

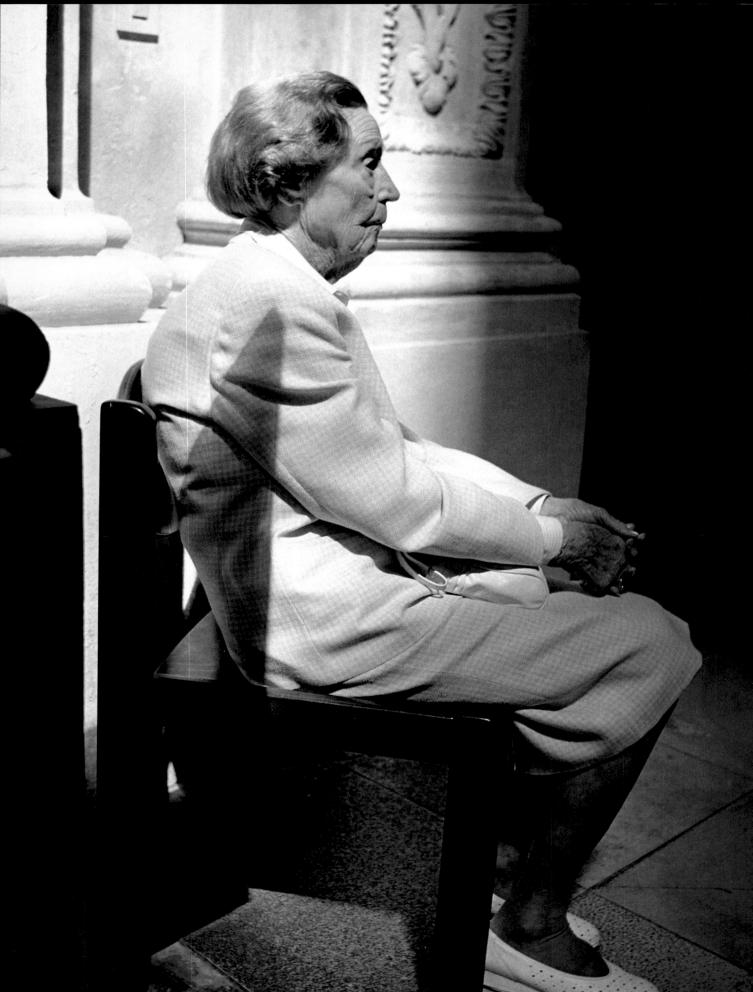

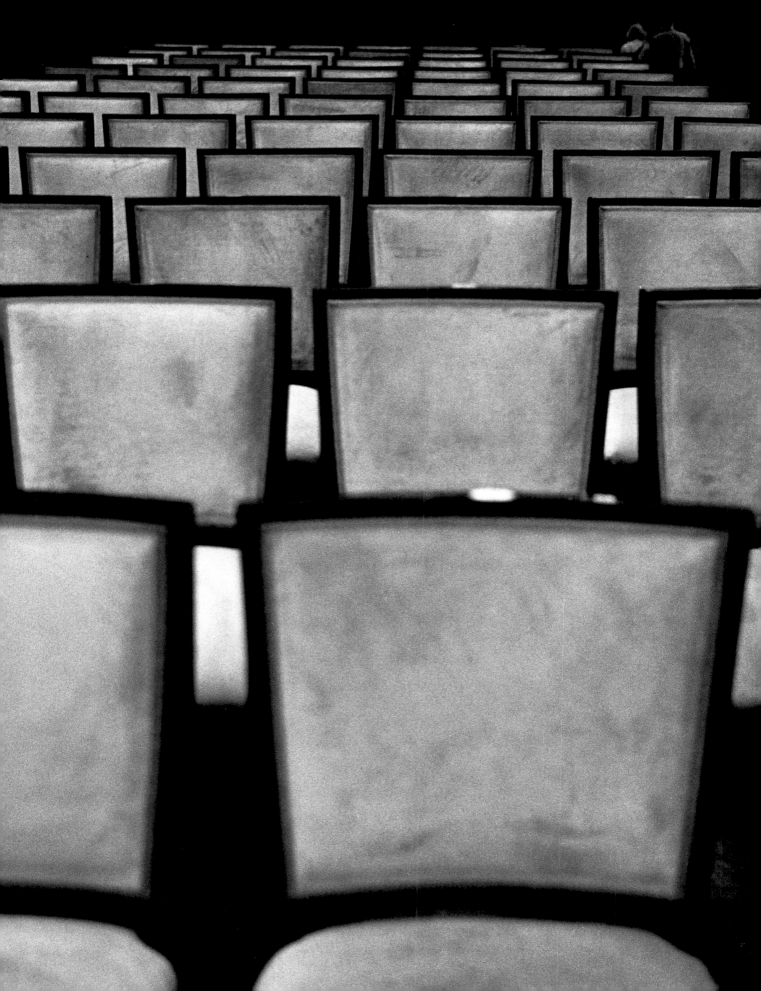

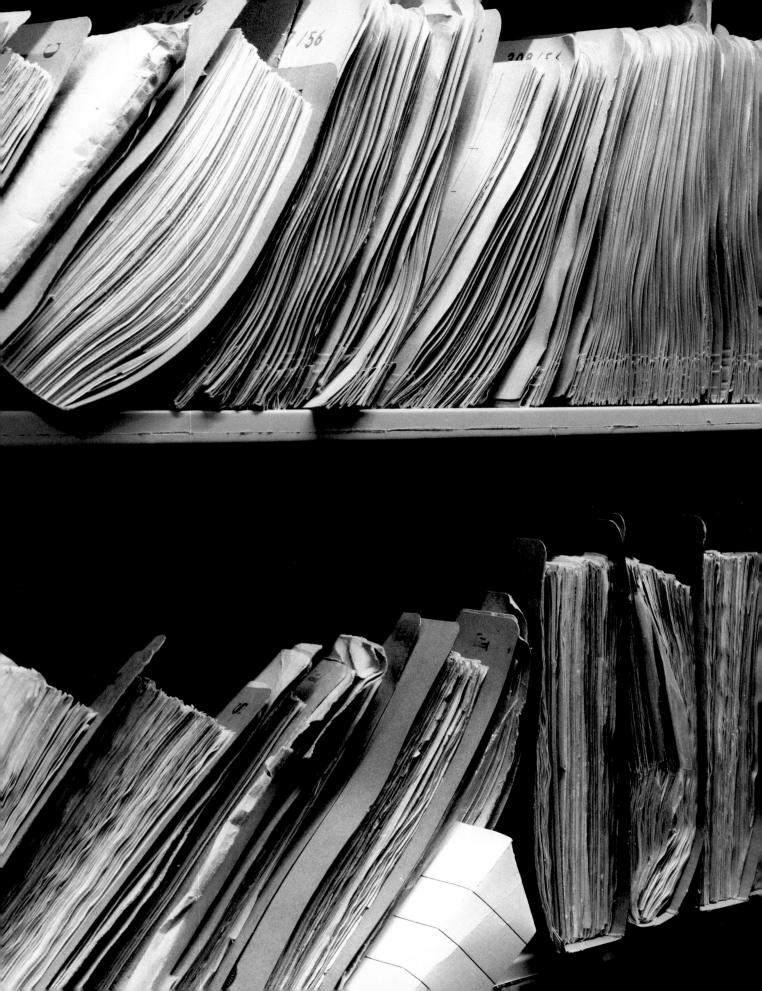

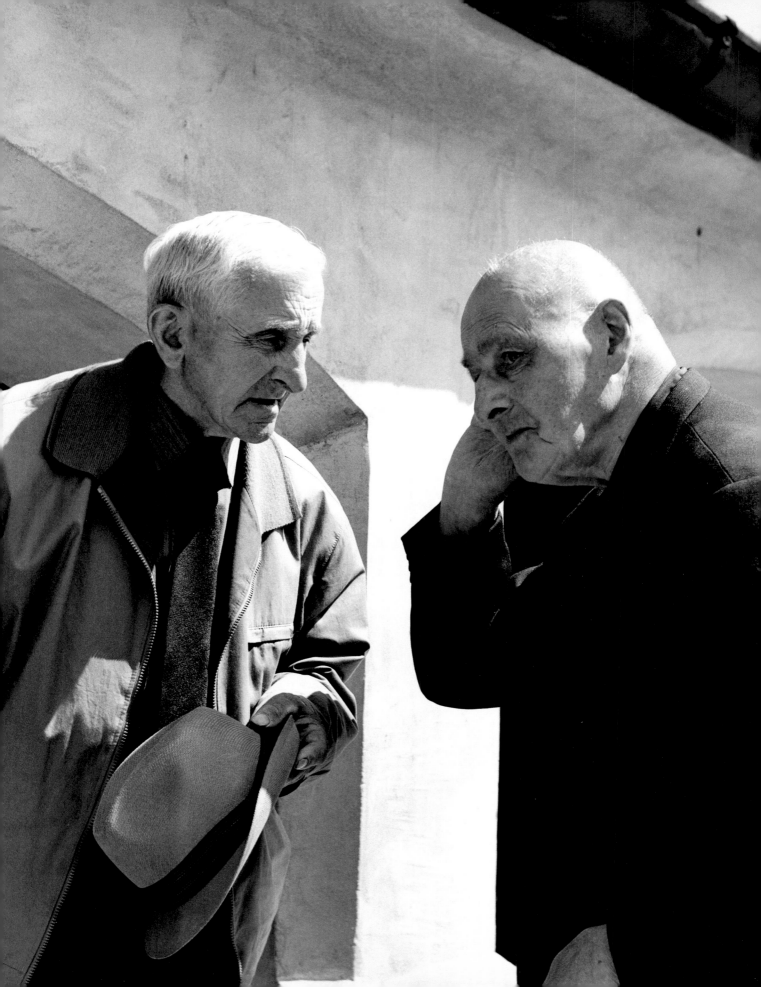

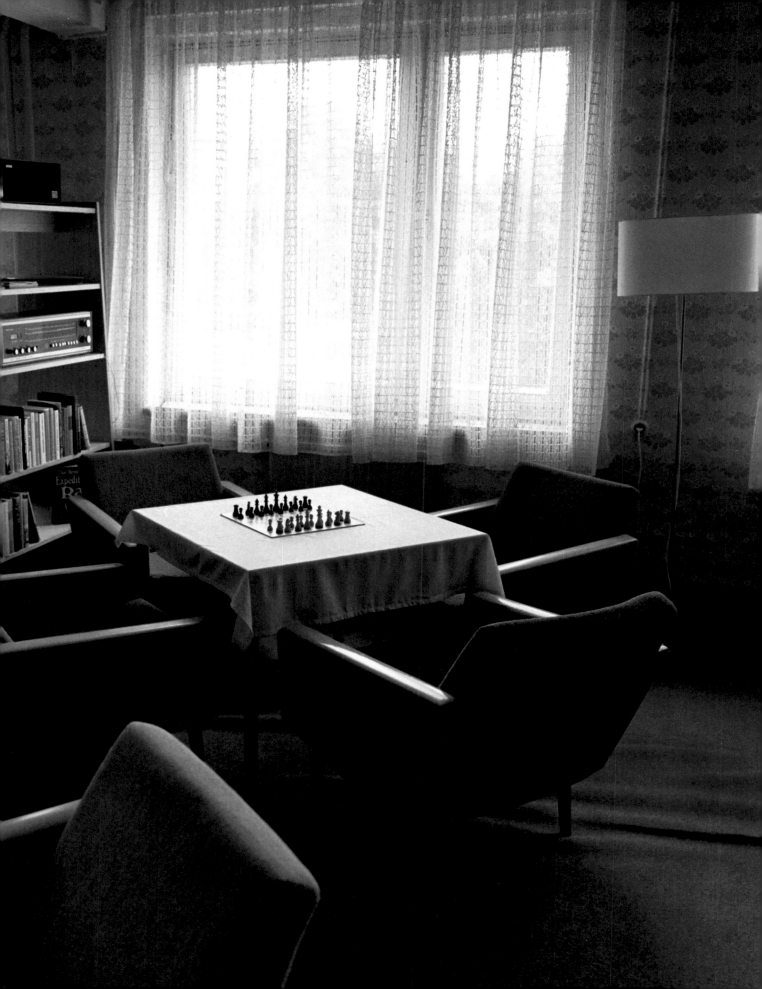

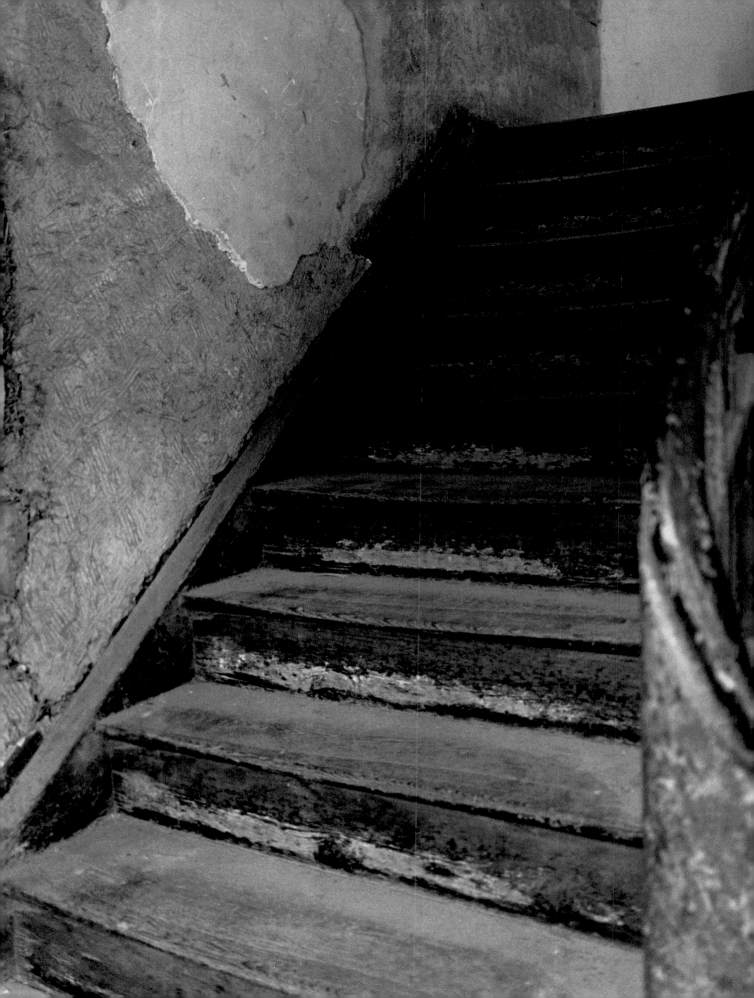

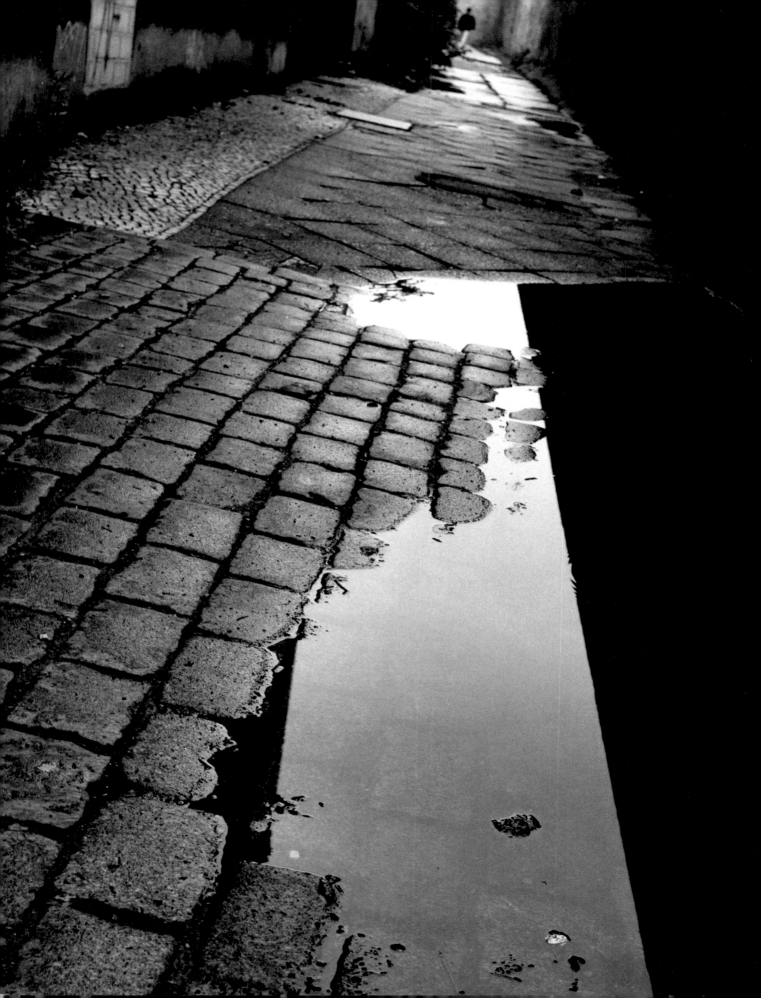

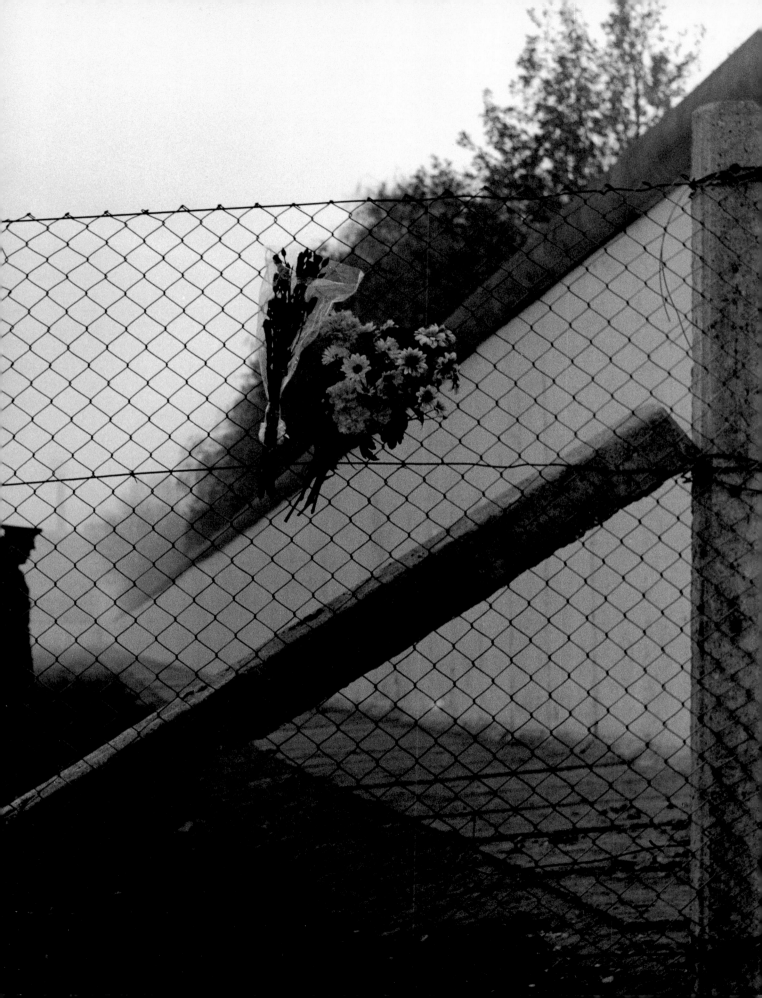

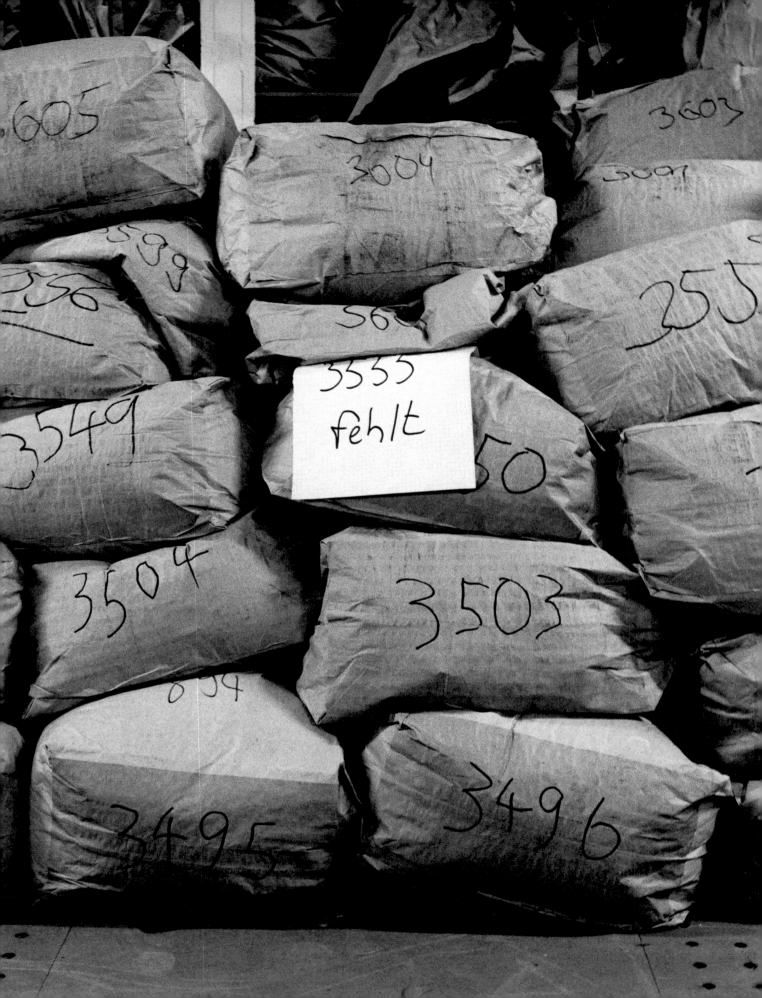

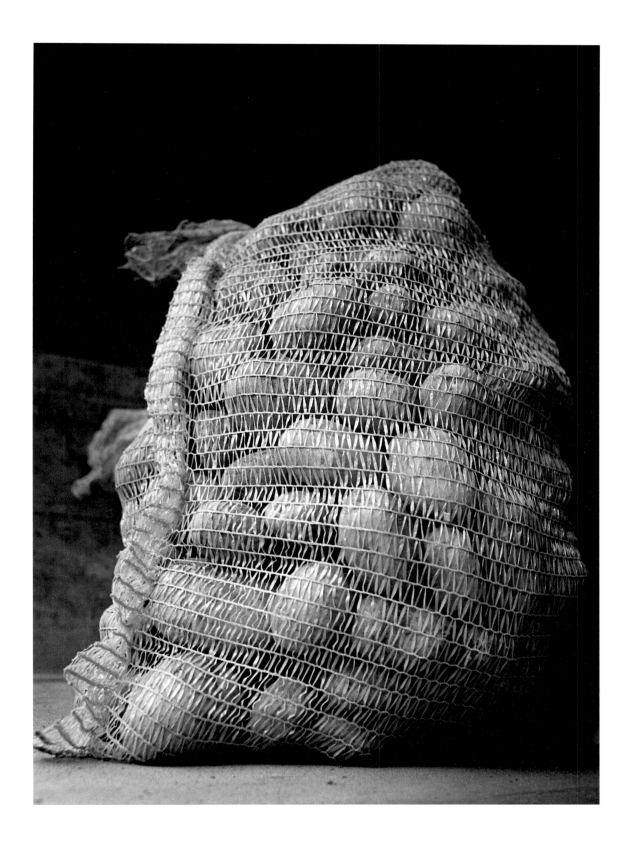

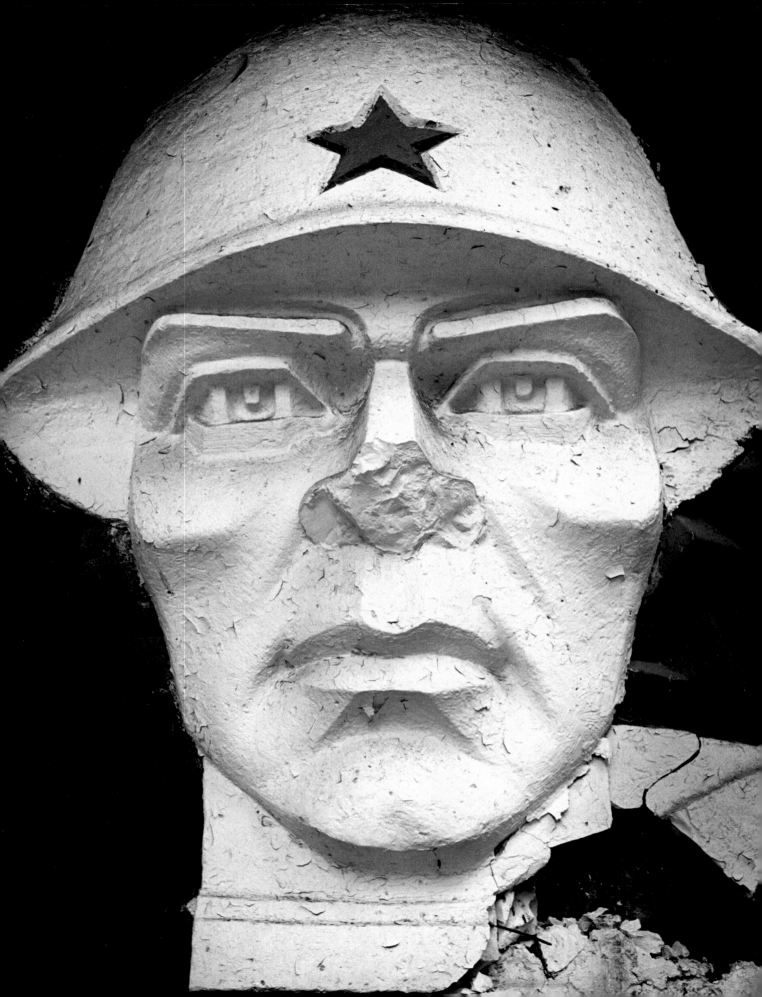

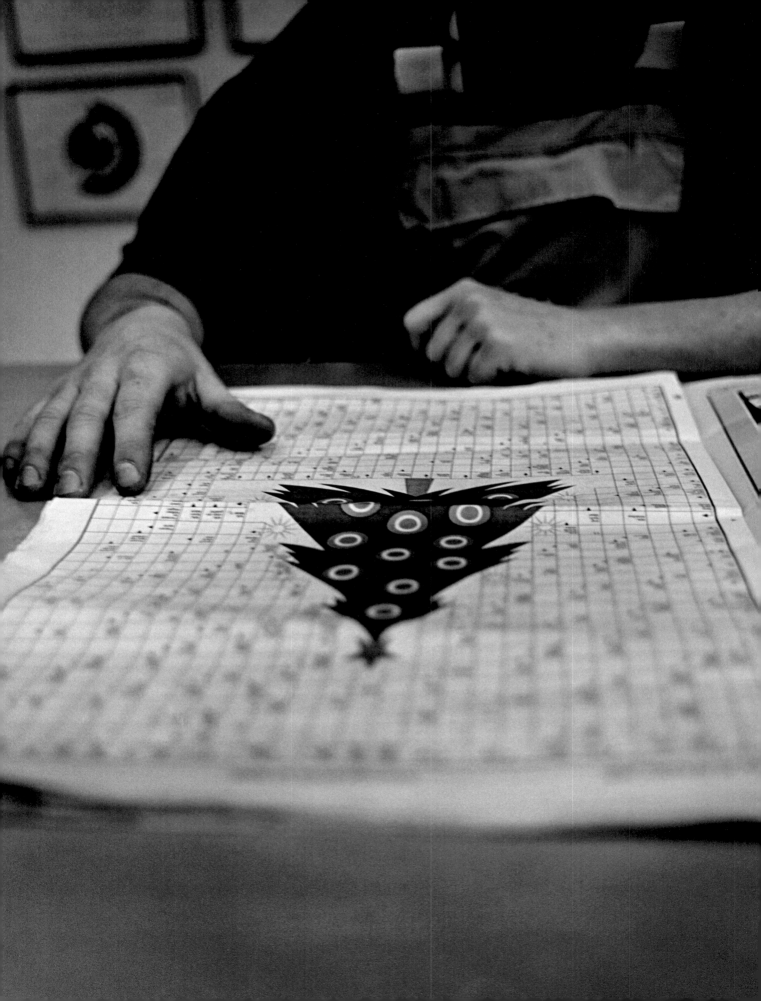

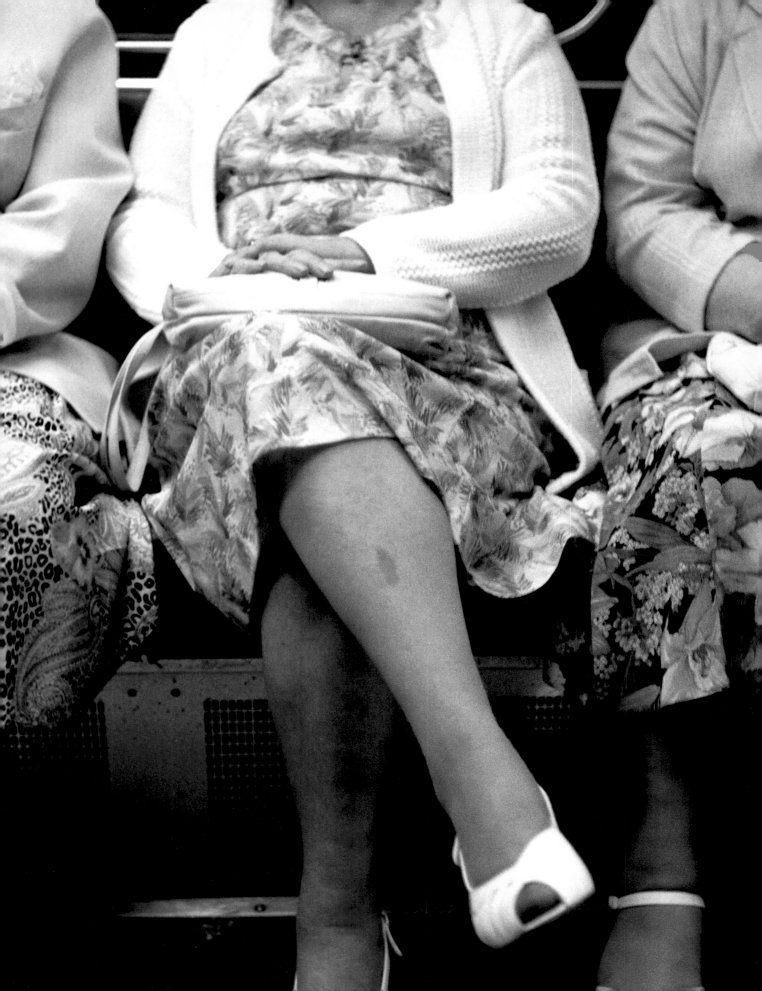

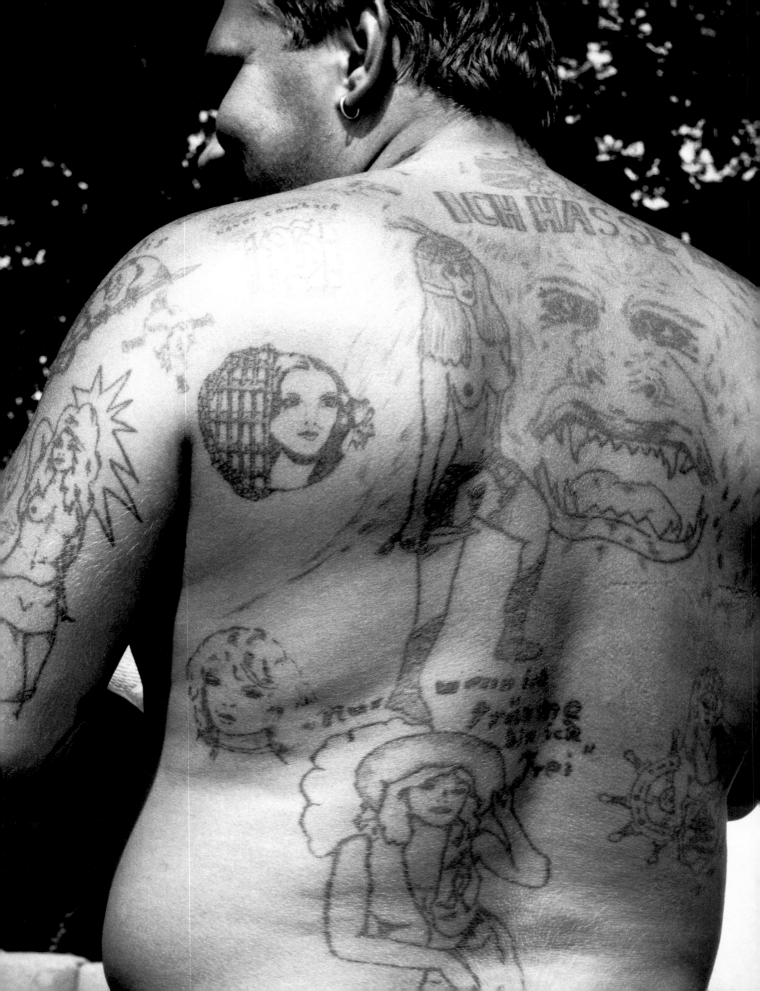

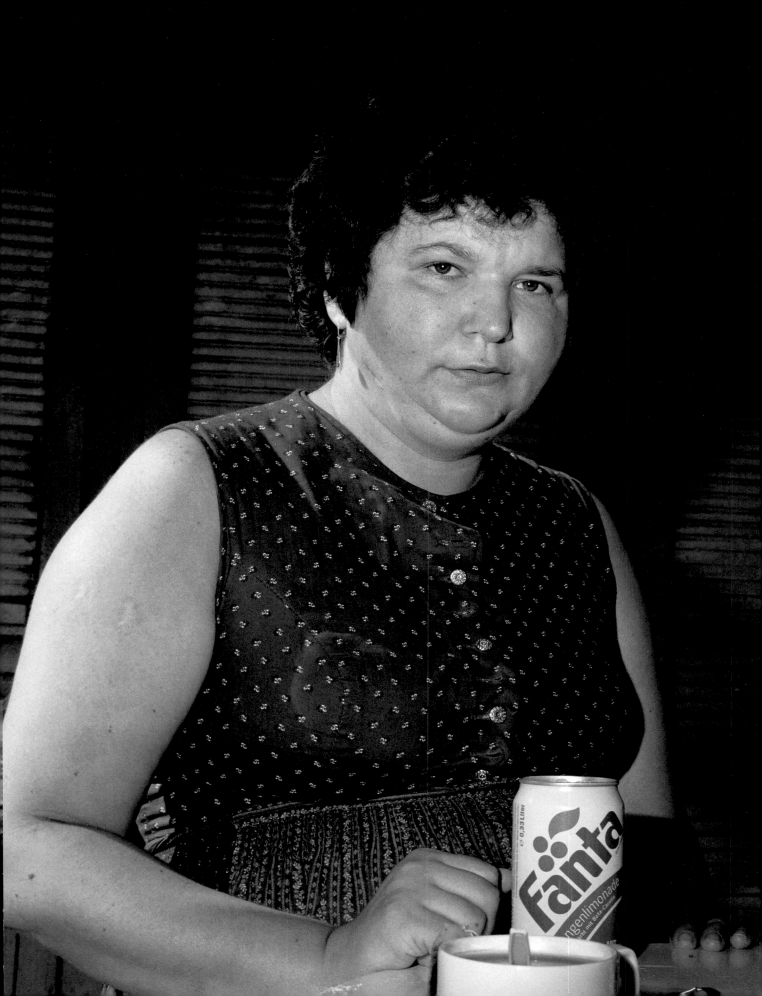

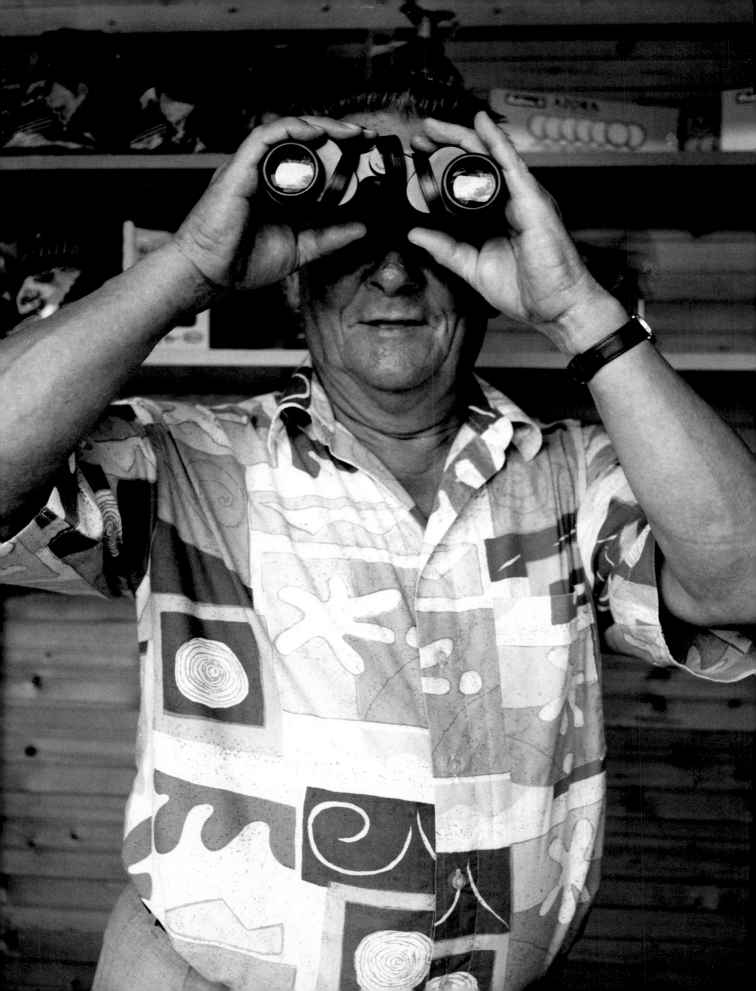

Original Home

Cut off feelings, fragments of smells and doubts and floral patterns.
I collected all of these things inside the cigarette boxes of my father,
pieces of a lost home. Places follow each other, Athens – Munich –
Perugia – Berlin – Samos – New York – Bridgehampton, endless
connecting lines between places and people. At a certain point
the search for home ends. Bastienne Schmidt 2004

Urheimat

Abgeschnittene Gefühle, Fragmente von Gerüchen, Zweifeln und
Blümchenmustern habe ich gesammelt in den Zigarettenschachteln
meines Vaters, Stücke der verloren gegangenen Heimat. Sich
aneinander reihende Orte, Athen – München – Perugia – Berlin –
Samos – New York – Bridgehampton, endlose Verkettungen,
Verbindungslinien von Orten und Menschen. Irgendwann hört
die Suche nach der Heimat auf. Bastienne Schmidt 2004

A Little Local Studies

HANNS ZISCHLER

From the direction of home
Behind the red flashes of lightning
There come clouds
Joseph von Eichendorff

The others, who might speak our language, but only partially understand it, have difficulties with this word. *Heimat* seems to mean something that is so simple in German that it escapes a closer definition by itself. It refers to a root – *Heim* – and beyond that, to something prelinguistic. It is just as if the language itself also has a (naturally dark) prehistory and early history (this strange word pair – *Vor- und Frühgeschichte* – too is only to be found in German) alongside its history and present. We must establish that it is – as if we can call after the others who have already turned away resignedly – a regular secret word, a coin that has fallen out of the circulation, from commerce. Alone the sound of the words, this slightly extended final syllable *-at*, suggests something final and complete just like the German words *Zierr*at (decoration) and *Klein*od (jewel). This word that knows no plural (because it is only valid for us) encloses and holds something, with which German speakers imagine themselves to be close and united. It belongs to them completely alone, even if the others can't understand this at once.

Little elucidation is provided by the semantic fields lying wide around this word. Yiddish, the most recent and mobile among the German dialects, has still taken up most from the Middle High German word *heim*: *héjm*, *héjmisch* and *héjmland,* these stand for *gemütlich* (comfortable) (another little German puzzle) and warm, for a happy household and agreeable warm hearted characteristics of our nearest.

Heimat is an index. It describes the place, which the natives come from and in which the strangers stand out, even if they do behave unobtrusively, thanks to a lack of attachment to their roots. Defining it as a place is still too narrow, too abstract. We should rather talk about a space: the space of the community. Community relates towards society just like the native to the citizen. Society is that beyond *Heimat*. Homeless intellectuals devised it in the winter of the eighteenth century and provided it with operating instructions. No tribal inhabitants can identify themselves with this construction. The social is an abstract neighbourhood whose warmth, in as much as it can be felt at all, is unalterable district heating. The presociety community rests upon a recognizable size and a space that is belonging to it alone (even and exactly when this is increased to the geographic phantasm of *Volksgemeinschaft* ("national community")). The community and the space, in which it is at home in, would be the real, society the unreal. That is how the locals see it. Strangers live in the society and come from within it. Anonymity cannot be found in the *Heimat*. Everybody knows each other, and anyone they don't know doesn't belong there. The paradox, that many people tied to their roots are also simultaneously socially acceptable citizens, only seems to astonish someone, who has not yet experienced at first-hand, how quickly you can slip from the role of an arrogant motorist into that of a car-despising cyclist.

Emigrants are specialists on everything local. Hungarian emigrant George Mikes wrote a book entitled *How to be an Alien* after several years' exile in England. Another Hungarian, director George Cukor, had to use a large sign in front of his office: "It's not enough to be Hungarian!" in order to ward off the rush of his fellow countrymen in Hollywood.

The renowned Polish poet Adam Zagajewski describes how disconcerting the procedure of becoming local in new surroundings can be in his memoirs *Two Cities*. His family's hometown was Lemberg, the former Galician city that became eastern Polish after 1918 (which I would call Lwow, if I were Polish, which would then become Lemberg again in the German translation). In 1945 they were all expelled. They were resettled in Gleiwitz, a city that was now under Polish administration, in accordance with the Potsdam Agreement. The adults refused to unpack their suitcases, let alone relate to this "German" city at all. They lived in the irrefutable certainty that they would very soon return to Lemberg, which was under temporary Soviet occupation. This results in an unintentional yet unavoidable ghostly division of space and even *Heimat* within one and the same family, when grandfather and grandson go walking through the city together: "So I wandered with my grandfather through the streets of Gleiwitz, but in reality we walked through different cities. I, a brash little guy with a memory as tiny as a hazel nut, strolled through the streets of Gleiwitz, between Art Nouveau style Prussian residential buildings, decorated with heavy caryatids made out of granite. I was completely aware that I was there where I was. My grandfather, by contrast, even though he was walking along next to me, was simultaneously in Lemberg. I went through Gleiwitz streets, he through Lemberg ones. I was in a long street, they would definitely have called Main Street in America. Here, though, they named it Victory Avenue, a mocking name after so many defeats. It linked the small market square with the similarly moderately sized station. At the same time, though, grandfather was walking through the Sapieha Road in Lemberg. Then, for a change, we entered Chrobry Park (the Polish king was supposed to Polonize the German trees), but he was naturally in the Jesuit garden in Lemberg."

In my childhood, refugees from a Bohemian village north of Prague lived in our house in the Franconian Jura (in northern Bavaria) for several years. They spoke a German that was so soft-singing and unusually articulated that it seemed to drift through the house. It seemed quite strange to me, because after all, until then I had only known the hard, chunky and seemingly swallowed Franconian scraps of my village. The grandfather of the refugee family, a double of my own, would get lost for days at a time in the forests. He took me with him whenever we could manage. One summer's day he returned from the forest with magnificent mushrooms and spread them out in front of my grandmother. It was a gift. The old lady rejected them very determinedly. She also didn't want to be impressed by the nature-lover's infallible knowledge of mushrooms. Finally, he said: "Where I come from, everyone eats these mushrooms." "Yes, where you come from" was her pithy reply.

Kleine Heimatkunde

HANNS ZISCHLER

Aus der Heimat hinter den Blitzen rot
Da kommen die Wolken her
Joseph von Eichendorff

Die andern, die unsere Sprache vielleicht sprechen, aber nur teilweise verstehen, haben Schwierigkeiten mit diesem Wort. Es hat den Anschein, als sei mit „Heimat" etwas gemeint, das so allgemein verständlich ist, dass es sich einer näheren Bestimmung wie von selbst entzieht. Es verweist auf einen Stamm – Heim – und darüber hinaus, auf etwas Vorsprachliches, so als habe auch die Sprache selbst, neben ihrer Geschichte und Gegenwart, eine – natürlich dunkle – Vor- und Frühgeschichte (auch dieses seltsame Wortpaar gibt es nur im Deutschen). Es ist, so muss man feststellen und kann den andern, die sich schon resigniert abgewendet haben, nachrufen, es ist wohl ein regelrechtes Geheimwort, eine aus dem Kommerz, der Zirkulation herausgefallene Münze. Allein der Wortklang – diese leicht gedehnte Endsilbe -*at*, die ähnlich wie Zierr*at* und Klein*od* etwas Abschließendes und Abgeschlossenes suggeriert. Dieses Wort, das keinen Plural kennt (es gilt ja nur für uns), umschließt und birgt etwas, dem die Deutschsprachigen sich nahe und verbunden wähnen, das ihnen ganz allein gehört, auch wenn die andern dies nicht gleich verstehen können.

Die Wortfelder, die breit um dieses Wort herum lagern, tragen nicht viel zur Erhellung bei. Das Jiddische, der jüngste und beweglichste unter den deutschen Dialekten, hat von dem mittelhochdeutschen Wort *heim* noch am meisten aufgenommen: *héjm*, *héjmisch* und *héjmland,* diese stehen für gemütlich (ein weiteres kleines Rätsel) und warm, für einen glücklichen Haushalt und wohltuende, warmherzige Eigenschaften unserer Nächsten.

Heimat ist ein Index. Er bezeichnet den Ort, aus dem die Eingeborenen kommen und an dem die Fremden auffallen, auch wenn sie sich unauffällig verhalten – mangels Heimatverbundenheit. Ort ist noch zu eng gefasst, zu abstrakt, man sollte eher von einem Raum sprechen, dem Raum der Gemeinschaft. Gemeinschaft verhält sich zur Gesellschaft wie der Eingeborene zum Bürger. Die Gesellschaft ist das Jenseits der Heimat, sie wurde von heimatlosen Intellektuellen im Winter des achtzehnten Jahrhunderts ersonnen und mit einer Bedienungsanleitung versehen. Kein Stammesmitglied kann sich mit dieser Konstruktion identifizieren. Das Soziale ist abstrakte Nachbarschaft, seine Wärme, sofern sie überhaupt zu spüren ist, unbeeinflussbare Fernwärme. Die vorgesellschaftliche Gemeinschaft besteht auf einem erkennbaren Umfang und einem ihr allein zugehörigen Raum (auch und gerade wenn dieser zum geographischen Phantasma gesteigert wird: „Volksgemeinschaft"). Die Gemeinschaft und der Raum, in der sie heimisch ist, wären das Eigentliche, die Gesellschaft das Uneigentliche. So sehen es die Einheimischen. In der Gesellschaft leben und aus ihr kommen die Fremden. In der Heimat gibt es keine Anonymität. Man kennt sich, und wen man nicht kennt, der gehört nicht dazu. Das Paradox, dass viele Heimatverbundene gleichzeitig auch gesellschaftsfähige Bürger sind, scheint nur den zu verwundern, der noch nicht am eigenen Leib erfahren hat, wie rasch man von der Rolle des herablassenden Automobilisten in die des autoverachtenden Radlers schlüpfen kann.

Spezialisten für alles Heimatliche sind die Emigranten. *How to be an Alien* lautet der Titel eines Buches, das der ungarische Emigrant George Mikes nach einigen Jahren Exil in England geschrieben hat, während ein anderer Ungar, der Regisseur George Cukor, in Hollywood sich des Ansturms seiner Landsleute nur mithilfe eines großen Schildes vor seinem Büro erwehren konnte: „It's not enough to be Hungarian!"

Wie befremdlich das Heimischwerden in einer neuen Umgebung werden kann, schildert der polnische Dichter Adam Zagajewski in seinen Erinnerungen *Zwei Städte*. Seine ganze Familie war im Jahr 1945 aus ihrer Heimatstadt, dem ehemals galizischen und nach 1918 ostpolnischen Lemberg vertrieben worden (das ich, wäre ich Pole, Lwow nennen würde, was in der deutschen Übersetzung wieder zu Lemberg wird). Sie wurden umgesiedelt in das nunmehr laut Potsdamer Abkommen unter polnischer Verwaltung stehende Gleiwitz. Die Erwachsenen weigerten sich, ihre Koffer auszupacken, geschweige denn diese „deutsche" Stadt überhaupt wahrzunehmen. Man lebte in der unumstößlichen Gewissheit, sehr bald wieder in das vorübergehend sowjetisch besetzte Lemberg zurückzukehren. Und so kommt es unversehens, doch unabweislich zu einer gespenstischen Raum-, ja Heimatspaltung innerhalb ein und derselben Familie, wenn Großvater und Enkel gemeinsam durch die Stadt spazieren: „Ich wanderte also mit meinem Großvater durch die Straßen von Gleiwitz, in Wahrheit aber spazierten wir durch verschiedene Städte. Ich, ein forsches Kerlchen mit einem Gedächtnis winzig wie eine Haselnuß, war mir, während ich durch die Straßen von Gleiwitz schlenderte, zwischen preußischen Wohnhäusern im Jugendstil, verziert mit schweren Karyatiden aus Granit, dessen völlig bewußt, daß ich dort war, wo ich mich befand. Mein Großvater hingegen, obwohl er neben mir herging, befand sich im selben Moment in Lemberg. Ich ging durch Gleiwitzer Straßen, er durch Lemberger. Ich befand mich in einer langen Straße, die in Amerika sicher Main Street hieße, hier aber (nach so vielen Niederlagen) den höhnischen Namen Siegesallee trug und den kleinen Marktplatz mit dem ebenfalls mäßig großen Bahnhof verband, Großvater aber spazierte zur selben Zeit durch die Sapiehastraße in Lemberg. Dann betraten wir zur Abwechslung den Chrobry-Park (der polnische König sollte die deutschen Bäume polonisieren), er hingegen befand sich selbstverständlich im Jesuitengarten in Lemberg."

In meiner Kindheit wohnten in unserem Haus im fränkischen Jura für einige Jahre Flüchtlinge aus einem böhmischen Dorf nördlich von Prag. Sie sprachen ein Deutsch, das mir, weil es so singend weich und ungewöhnlich artikuliert durchs Haus wehte, ganz fremdartig vorkam, kannte ich doch nur die harten, klobigen und wie verschluckten fränkischen Brocken meines Dorfes. Der Großvater der Flüchtlingsfamilie, ein Double meines eigenen, verlor sich ganze Tage in den Wäldern. Wenn es sich machen ließ, nahm er mich mit. An einem Sommertag kehrte er mit prächtigen Pilzen aus dem Wald zurück und breitete sie vor meiner Großmutter aus. Eine Gabe. Sehr entschieden wies die alte Dame das Geschenk zurück, wollte sich auch nicht von der untrüglichen Pilzkenntnis des Naturfreundes beeindrucken lassen. Als er schließlich sagte: „In meiner Heimat essen alle diese Pilze", entgegnete sie knapp: „Ja, in Ihrer Heimat."

Shadowland

ANDRIAN KREYE

It was the evening of the Fourth of July on the bank of the East River. Just after sundown on a glorious summer's day, the pyrotechnicians fired colorful ornaments into the sky above New York from a barge in the river. Everyone around us was ready and tuned-in to the radio station, just moments away from playing the music to which the ensuing fireworks were meticulously choreographed. Then the disc jockey began playing *God Bless America,* as the spectacle commenced into brilliant bursts of red, white and blue. Irving Berlin had once written this patriotic hymn for a musical, but it now serves as America's unofficial national anthem. A woman's voice quavered its way up the harmonies. With each halftone, raised higher with each passing verse, the people by the river held hands a little tighter, while others carefully wiped away tears shed from the corner of their eyes.

Such an outburst of patriotic emotions tends to embarrass us Germans. At best, we defuse the moment with a joke, just as often though we find ourselves frowning. We know that hardly any term is as emotionally loaded as *Heimat.* In our polite, reserved Germany, so tormented by her past, so unsure in her present, there is huge reluctance to allow any patriotic emotions outside of soccer and the arts. Too often in our history, the term *Heimat* (meaning home) had been mistaken for nation and *homeland.* The term is far too loaded to permit passion. That's why any German experiencing the pathos during the fireworks for the Fourth of July in the USA, the frenetic celebrations for *Cinco de Mayo* in Mexico or the French pride on the *Jour de la Bastille* for the first time, might also be experiencing for the first time how fervently people can celebrate their country.

As West Germans who were too young for the '68 generation's anger toward their country and too old for the national identity search of the young people who came of age after the fall of the Berlin Wall, we grew up rather indifferent to Germany. That kept us sober and realistic, and protected us against sentimentalities and romanticization. It also made it easier for many of us to leave Germany. Anyone who doesn't really love his or her country becomes immune to the pains of uprooting.

That made us so much more cosmopolitan and there are of course few cities where the rootless, restless wanderers between worlds and cultures feel more at home than in New York. Nobody really belongs here, so for many, *home* assumes a very different kind of meaning. It can be found in thoughts, ideas and people. What *home* once meant might even be forgotten. Until it catches up with you once more, but that is precisely what sharpens the view of origins.

I had been living in America for six years when it became clear to me during a visit to Moscow, of all places, how distant I had already become from my roots and my past in Germany. It was one of those late summer afternoons on which the sun can still warm floors and walls, but you can already smell the dampness of the approaching fall. An afternoon when the sounds and voices of the warm air are carried with that homely directness that tells you even with closed eyes that it is summer, but the sunbeams with the illusion of gold-colored light shortly before the evening obscure the fact that they have already become so much paler. It was

this play of smells, sounds and light that all of a sudden brought back the Munich of my childhood. I couldn't even stand Moscow, that hostile, gloomy, rough city. I had always felt much better in the friendly, light-hearted, playful America, and yet at this moment Moscow felt more home than New York. A city that smelt, sounded and shone so differently.

This conflict between familiarity and strangeness is precisely what determines the view when you've been away from Germany for awhile. It is a conflict between Eastern and Western Europe. No place might be more removed from this conflict than Munich. Since the fall of the Berlin Wall it has gone through the least changes of all the German cities. For that reason, people in Munich tend to be surprised when they suddenly face these changes and conflicts. During an evening meal with theater people, artists and journalists, I was asked what struck me most as a rare guest in Germany. All that came to mind was the changing cultural climate. Germany was finding its way back to its roots in the east. The person who had asked reacted almost shocked, as if this were a fault. But Germany really doesn't have a choice. Neither belonging to the East nor the West she is facing once more her roots in Central Europe.

Earlier we only too willingly overlooked the aloof and serious, the hostile, gloomy and rough sides of the country. In West Germany we belonged to the West, while the East was sequestered literally behind a wall. We were much more familiar with Paris, New York and the Californian Pacific, than Dresden, Berlin and the Baltic Sea.

Now though, Germany is again searching for her roots. The transformations are hardly noticeable for us West Germans. They are as subtle as smells, sounds and the play of light on a summer's afternoon. The subtle changes might show in aesthetics, be felt in words and gestures. This might remain subtle, as long as the land still shies away from mystification, the cultural side of that ardent love of one's country, which we find in so many other places.

Here, too, the past weighs heavily. The first attempts seem clumsy, virtually awkward. Nowhere can you see this as well as in Berlin. I returned for the first time after seven years and walked through the new government district. Spontaneously I thought about the essay *The Crocodiles of Yamoussoukro* by V.S. Naipaul. In this, he tells of the capital of the Ivory Coast, a monumental fantastic form in the midst of the savannah. Félix Houphouët-Boigny, the first President after the withdrawal of the French colonial masters, transferred the seat of government to his home village. He built splendid boulevards and government palaces and in addition a copy of St. Peters bigger than the original.

There it was, the new Berlin-Mitte district with its oversized government buildings, its lonely prosecco bars and its deserted shopping arcades. It had postured itself a little too much as the great German metropolis, the gateway to the east and a golden future. A vision only Helmut Kohl believed in the end. If you indeed wanted to find the new Germany, you would have to dig deeper in its niches and cracks. Deep in its heart,

Berlin has remained exactly the same exciting ruined city, where subcultures have been searching for the German soul, undisturbed for decades. This is because on the ruins of the past, there was only a present and never a future.

Very slowly, the new Germany is seeping into the light from these niches and cracks. You will find her in music, painting, independent cinema, and in literature. She is a friendly, clever, relaxed Germany, representing neither the Central European powerhouse, that the country's rulers dream of, nor the center of western culture which so many long for.

In that summer of my first visit for years, I stood on a roof high above Berlin-Mitte with some friends, who had returned from the US to Berlin. We gazed at the panorama of domes, towers, and gables, with summer light shimmering above. We felt strange in this city full of hostility, gloom and despair, and yet in this moment, it was home once more. It was this mixture of smells, sounds and light, which had followed us here from our childhoods like a shadow. Maybe we would never again feel completely at home in Germany, never again see the country with the eyes of a native. Still it would always stay close to us, no matter if we saw our country with passion, doubt or alienation.

Schattenland

ANDRIAN KREYE

Es war der Abend des vierten Juli am Ufer des East River, kurz nach dem Sonnenuntergang eines prächtigen Sommertages, die Pyrotechniker schossen von einer Barke im Fluss schillernde Ornamente in den Himmel über New York und alle Radios des Viertels waren auf jenen Sender eingestellt, der die Musik spielte, zu der das Feuerwerk choreographiert war. Wie jedes Jahr legte der Discjockey kurz vor dem Höhepunkt *God Bless America* auf, einen hymnischen Schmachtfetzen, den Irving Berlin einst für ein Musical geschrieben hatte und der heute als inoffizielle Nationalhymne Amerikas dient. Eine Frauenstimme tremoliert sich da die Harmonien hinauf. Bei jedem Halbton, um den sie die jeweils nächste Strophe anhob, hielten sich die Menschen am Fluss ein wenig fester an den Händen, und manche wischten sich vorsichtig eine Träne aus dem Augenwinkel.

So viel Heimatgefühl an einem Nationalfeiertag berührt uns Deutsche eher unangenehm. Bestenfalls retten wir uns dann mit einem Witz aus der Situation, oft runzeln wir aber auch missbilligend die Stirn. Wir wissen zwar, dass es kaum einen Begriff gibt, der so emotional aufgeladen ist wie „Heimat"; im höflichen, zurück-haltenden, von der Vergangenheit so gequälten und in der Gegenwart so unsicheren Deutschland gibt es da allerdings massive Berührungsängste. Zu oft wurde hier der Begriff Heimat mit Nation, Volk und Boden verwechselt, zu belastet sind die Worte, um Leidenschaft zuzulassen. Wer als Deutscher also zum ersten Mal das Pathos beim Feuerwerk zum *Fourth of July* der USA erlebt, die frenetischen Feiern zum *Cinco de Mayo* in Mexiko oder den französischen Stolz am *Jour de la Bastille*, der wird wahrscheinlich auch zum ersten Mal erleben, mit welcher Inbrunst Menschen ihre Heimat feiern können.

Wer nun zur westdeutschen Generation gehört, die für den Zorn der 68er auf die Heimat zu jung war und für die nationale Identitätssuche der Jugend, die nach dem Mauerfall erwachsen wurde, zu alt ist, der ist mit einem eher indifferenten Verhältnis zu seiner Heimat Deutschland aufgewachsen. Das hat uns nüchtern und realistisch gemacht, uns vor Sentimentalitäten und Romantisierung bewahrt. Vielen von uns ist es deswegen auch leichter gefallen, Deutschland zu verlassen. Wer die Heimat nicht mit Inbrunst liebt, der spürt auch den schmerzhaften Prozess der Entwurzelung nicht.

Das hat sein Gutes, denn wer aus Zwang geht, gilt als Flüchtling, wer freiwillig die Heimat verlässt, den nennt man einen Kosmopoliten.

Es gibt wohl kaum eine Stadt, in der sich diese wurzellosen, rastlosen Wanderer zwischen Welten und Kulturen wohler fühlen als in New York. Hier gehört niemand so wirklich dazu, dafür kann man hier ganz andere Heimatgefühle entwickeln, die sich losgelöst von der Geographie in Gedanken, Ideen und Menschen wiederfinden, die nichts mit der eigenen Herkunft zu tun haben müssen. Wie leicht ist es, hier seine Herkunft zu vergessen. Bis man von ihr wieder eingeholt wird, doch genau das schärft den Blick für die Heimat.

Das kann ein ganz banales Erlebnis sein. Ich lebte schon seit sechs Jahren in Amerika, als mir ausgerechnet bei einem Besuch in Moskau klar wurde, wie weit ich mich schon von meiner Heimat, meinen Wurzeln,

meiner Vergangenheit entfernt hatte. Es war einer jener Nachmittage im Spätsommer, an denen die Sonne Boden und Mauern immer noch erwärmen kann, aber man schon die Feuchtigkeit des nahenden Herbstes riecht, an denen die Geräusche und Stimmen von der warmen Luft immer noch mit jener anheimelnden Direktheit getragen werden, die einem auch mit geschlossenen Augen verrät, dass es Sommer ist, aber die Sonnenstrahlen mit der Illusion goldfarbenen Lichtes kurz vor dem Abend darüber hinwegtäuschen, dass sie schon so viel blasser geworden sind. Es war genau dieses Zusammenspiel aus dem unbestimmten Geruch der sommerlichen Stadt, den verwehten Sommerklängen und dem Lichteinfall, das mich für einen Moment in das München meiner Kindheit zurückversetzte. Dabei konnte ich Moskau nicht ausstehen, diese feindselige, schwermütige, grobe Stadt. Ich hatte mich in dem freundlichen, leichtfüßigen, verspielten Amerika schon immer wohler gefühlt und doch schien mir Moskau in diesem kurzen Moment vertrauter als New York, die Stadt, die so anders roch, sich so anders anhörte, so anders leuchtete.

Es ist genau dieser Konflikt zwischen Vertrautheit und Fremde, der den Blick bestimmt, wenn man schon lange aus Deutschland fort ist. Und es ist genau dieser Konflikt zwischen Ost und West, den man dort erkennt. Nirgendwo ist man diesem Konflikt wahrscheinlich so fern wie in München, das sich seit dem Mauerfall von allen deutschen Städten am wenigsten verändert hat. Deswegen ist das Erschrecken über die Veränderungen dort meist auch am größten. Es war bei einem Abendessen mit Theaterleuten, Künstlern und Journalisten, als mir auf die Frage, was mir als seltenem Gast in Deutschland am meisten auffalle, nur in den Sinn kam, das kulturelle Klima habe sich verändert, Deutschland finde zu seinen Wurzeln im Osten zurück. Der das gefragt hatte, reagierte erschrocken, als sei dies ein Tadel gewesen. Dabei bleibt Deutschland gar nichts anderes übrig, als diese Wurzeln wiederzuentdecken. Denn Deutschland ist nicht Ost-, nicht West-, sondern Mitteleuropa und somit die Schnittmenge aus beiden Himmelsrichtungen.

Nur zu gerne hatte man früher über das Spröde und Schwere hinweggesehen, über die feindseligen, schwermütigen und groben Seiten des Landes. In Westdeutschland hatten wir zum Westen gehört, der Osten lag hinter einer hohen Mauer. Paris, New York und der kalifornische Pazifik waren uns so viel vertrauter als Dresden, Berlin und die Ostsee.

Jetzt aber sucht Deutschland wieder nach seinen Wurzeln. Für uns Westdeutsche sind die Veränderungen kaum bemerkbar, sie sind so flüchtig und vergänglich wie die Gerüche, Geräusche und Lichtspiele eines Sommernachmittages, die den Wandel markieren. Eine Strenge in der Ästhetik. Eine Härte im Umgang. Das bleibt so subtil, solange sich das Land noch vor der Mystifizierung scheut, der kulturellen Seite jener inbrünstigen Heimatliebe, die man in so vielen anderen Ländern findet.

Auch da lastet die Vergangenheit schwer. Die ersten Versuche wirken unbeholfen, geradezu tollpatschig. Nirgendwo erkennt man das so gut wie in Berlin. Als ich nach sieben Jahren zum ersten Mal wieder dorthin zurückkam, fiel mir im neuen Regierungsviertel spontan die Reportage *Die Krokodile von Yamoussoukro* des Literaturnobelpreisträgers V.S. Naipaul ein. Darin erzählt er von der Hauptstadt der Elfenbeinküste,

einem monumentalen Phantasiegebilde inmitten der Savanne. Félix Houphouët-Boigny, der erste Präsident nach dem Abzug der französischen Kolonialherren, hatte den Sitz der neuen Regierung damals in sein Heimatdorf verlegt, prächtige Boulevards und Regierungspaläste gebaut und dazu eine Kopie des Petersdoms, die größer war als das Original.

Da stand das neue Berlin-Mitte mit seinen überdimensionierten Regierungsgebäuden, seinen vereinsamten Proseccobars und seinen verödeten Einkaufspassagen und hatte ein bisschen zu laut und zu viel von der großen deutschen Metropole gefaselt, vom Tor zum Osten und einer goldenen Zukunft. Daran hatte letztendlich doch nur Helmut Kohl geglaubt. Man musste tiefer schürfen, in die Nischen und Ritzen hinein, um das neue Deutschland zu finden, denn in Wahrheit war Berlin tief in seinem Herzen genau jene aufregende, chaotische Ruinenstadt geblieben, in der sich die Subkulturen seit Jahrzehnten so ungestört auf die Suche nach der deutschen Seele machen konnten, weil es dort auf den Trümmern der Vergangenheit nur eine Gegenwart und nie eine Zukunft gab.

Tropfen für Tropfen sickert das neue Deutschland aus diesen Nischen und Ritzen ans Licht. In der Musik, der Malerei, im unabhängigen Kino, in der Literatur. Ein freundliches, kluges, entspanntes Deutschland, das weder das mitteleuropäische Machtzentrum darstellt, das sich die Landesväter erträumen, noch das westliche Kulturland, nach dem sich so viele sehnen.

In Berlin-Mitte stand ich in jenem Sommer meines ersten Besuches nach vielen Jahren auf einem Dach. Freunde, die aus Amerika nach Berlin zurückgekehrt waren, präsentierten mir das Panorama mit den Kuppeln, Türmen und Giebeln, über denen das Sommerlicht flirrte. Wir fühlten uns fremd in dieser spröden, schwerfälligen, verzweifelten Stadt – und doch in diesem Moment auch wieder zu Hause. Es war diese Mischung aus Gerüchen, Geräuschen und Licht, die uns aus der Kindheit hierher gefolgt war wie ein Schatten. Vielleicht würden wir uns nie mehr ganz zu Hause fühlen in Deutschland, das Land nie mehr mit den Augen eines Einheimischen sehen. Doch die Verbundenheit würde uns bleiben, egal ob wir diese Heimat mit Leidenschaft, Zweifel oder Fremdheit sehen würden.

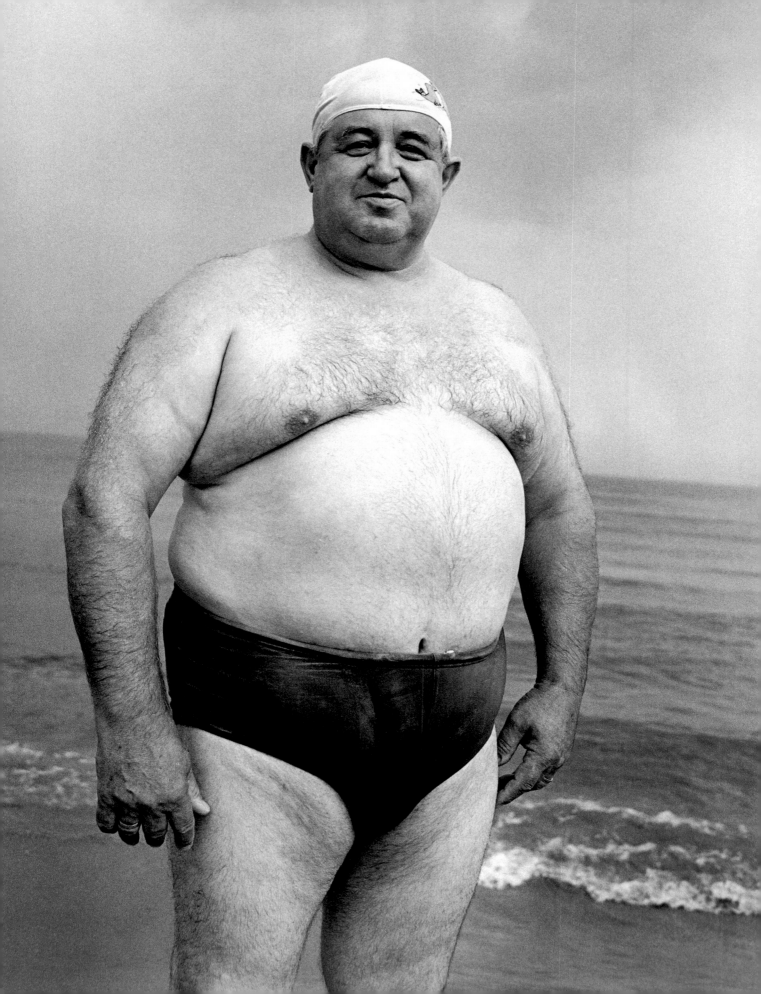

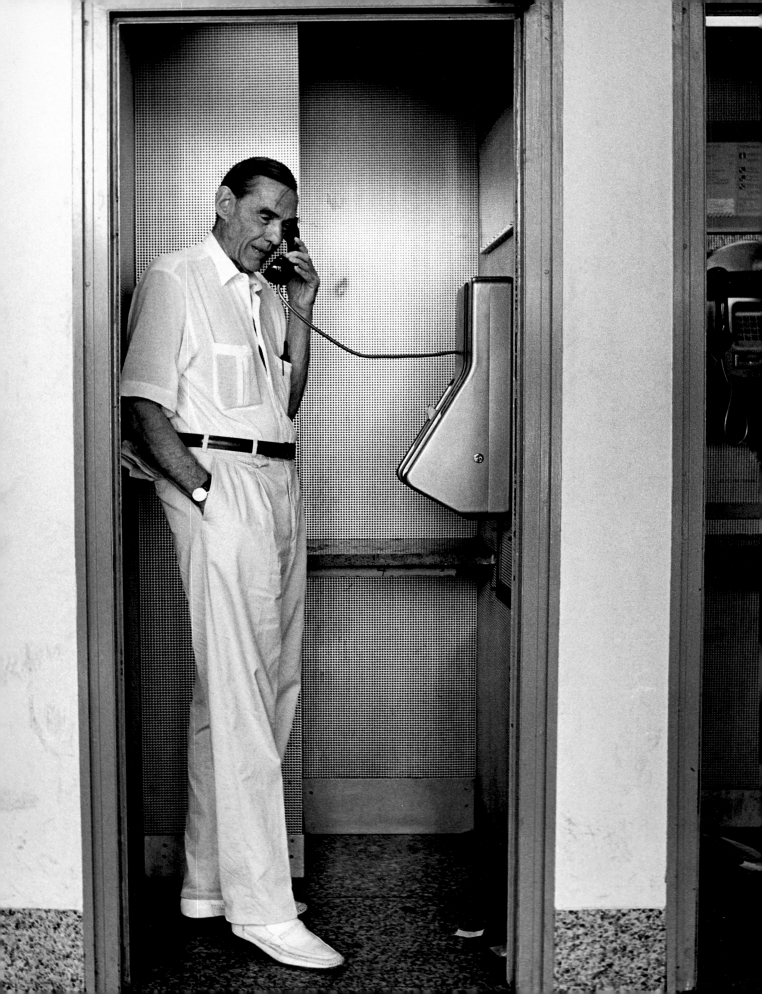

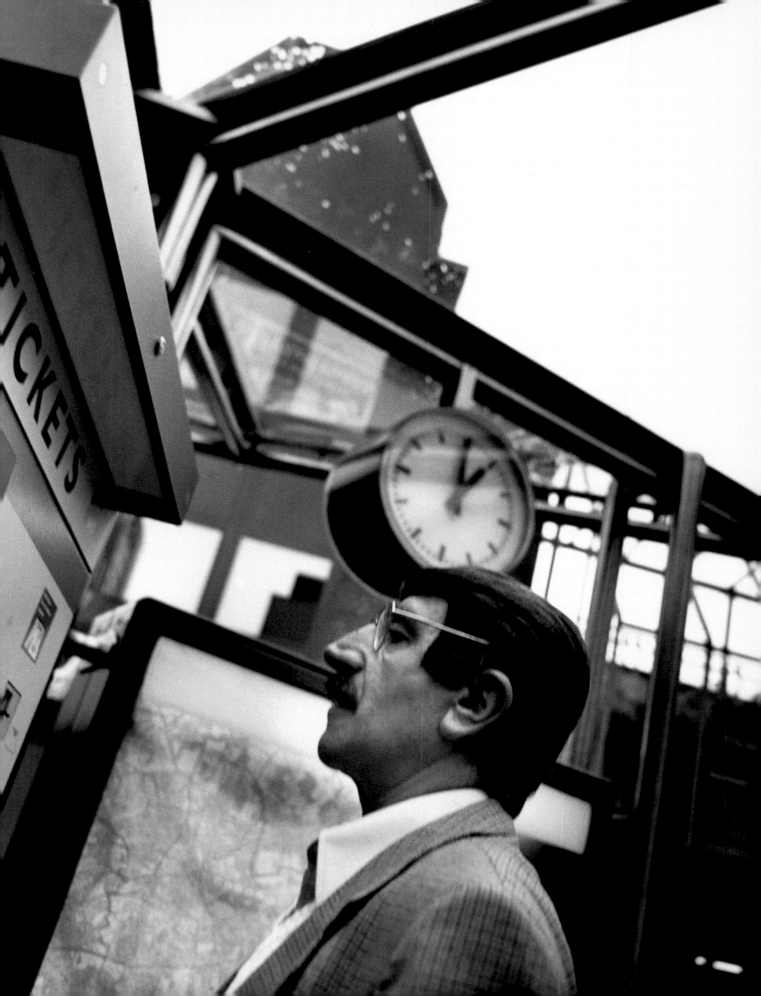

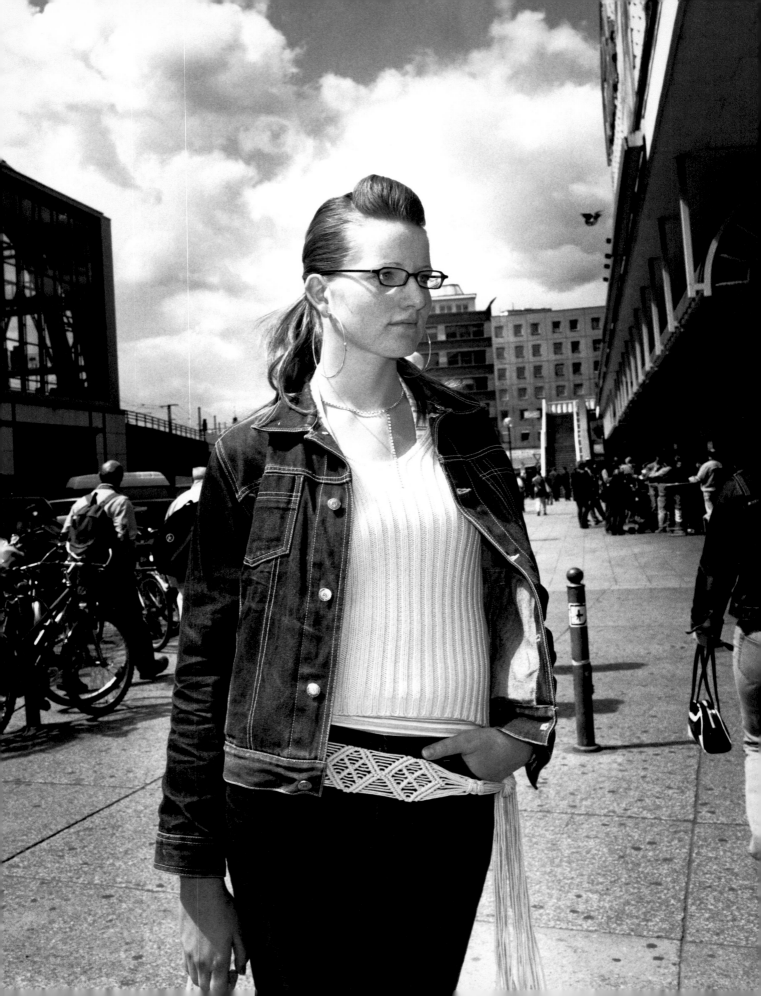

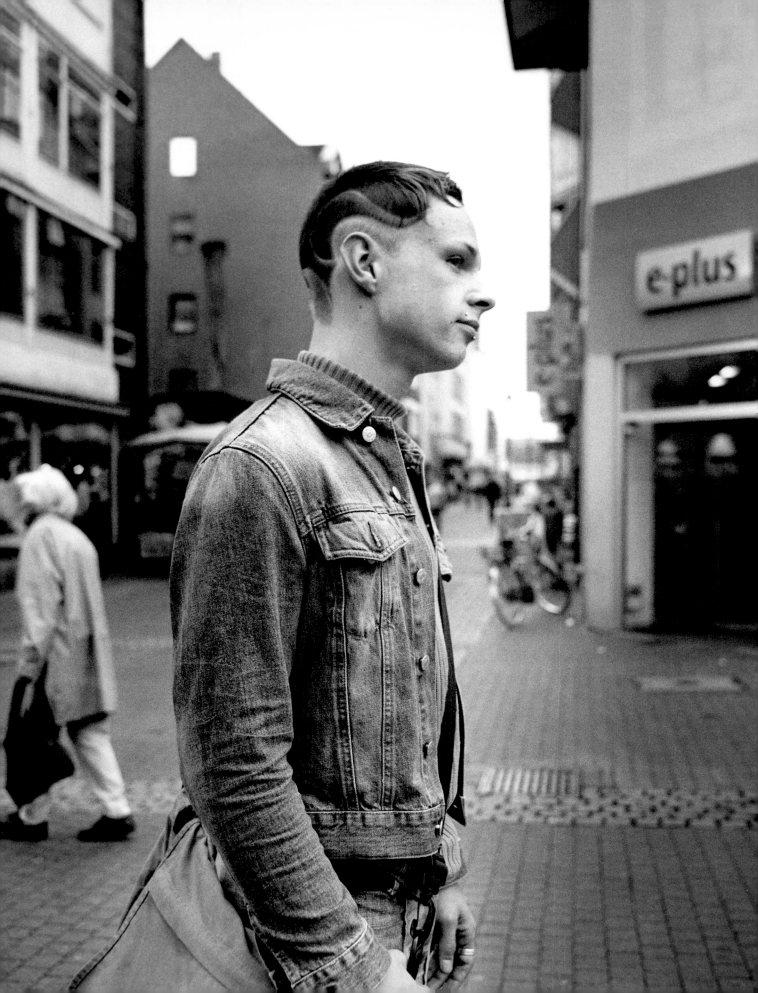

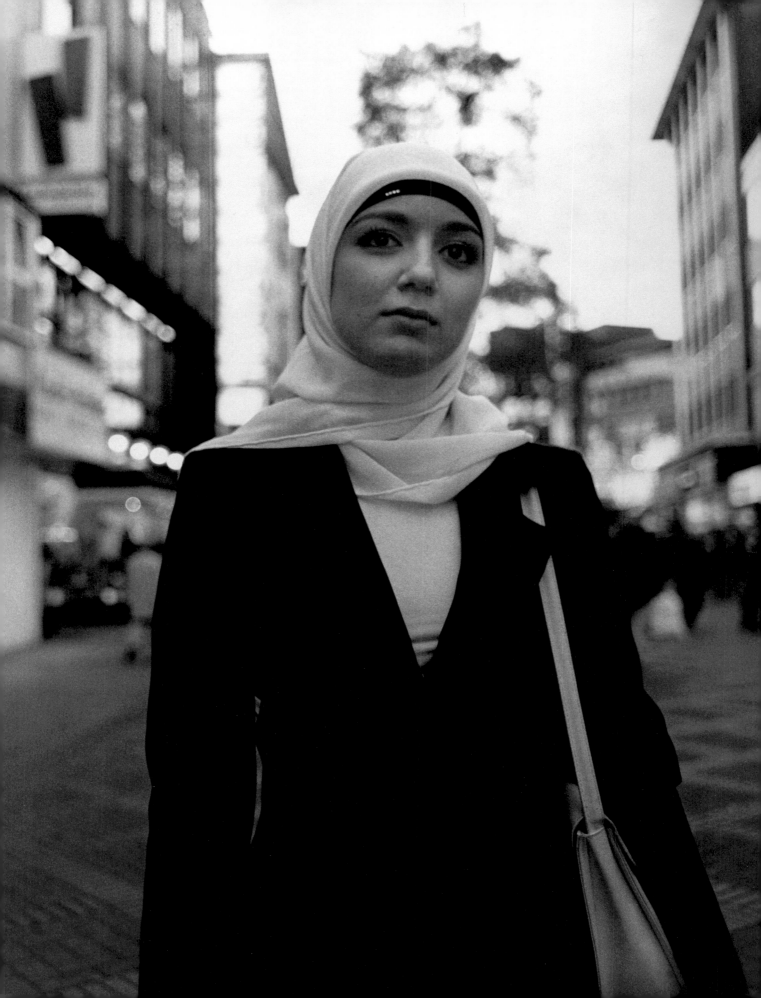

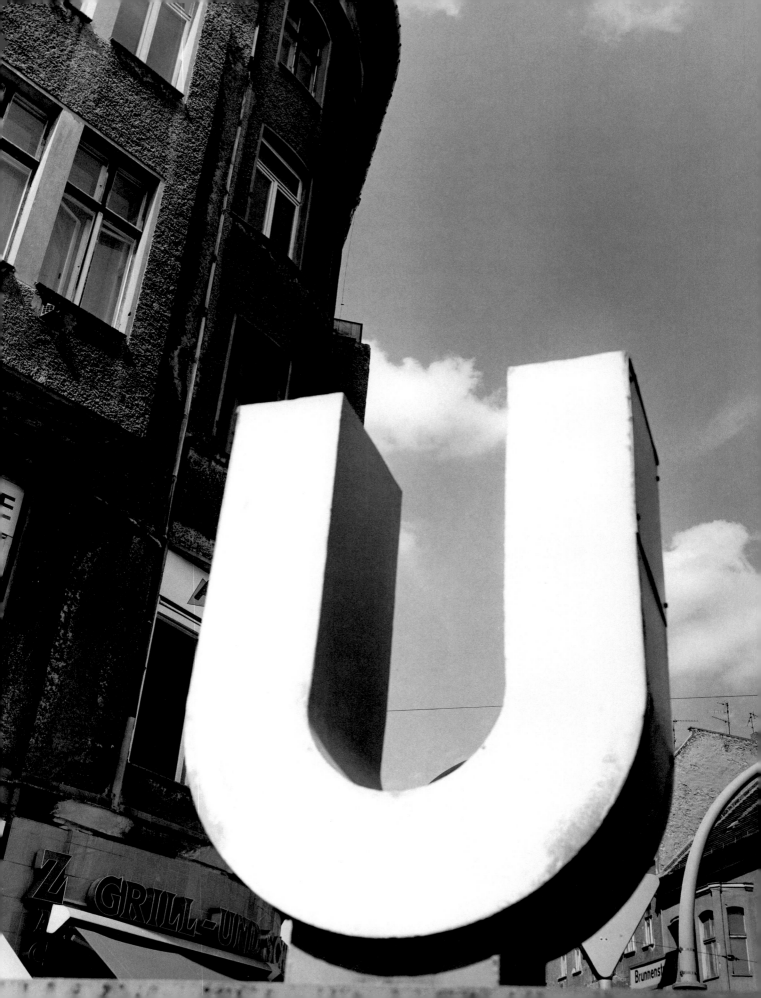

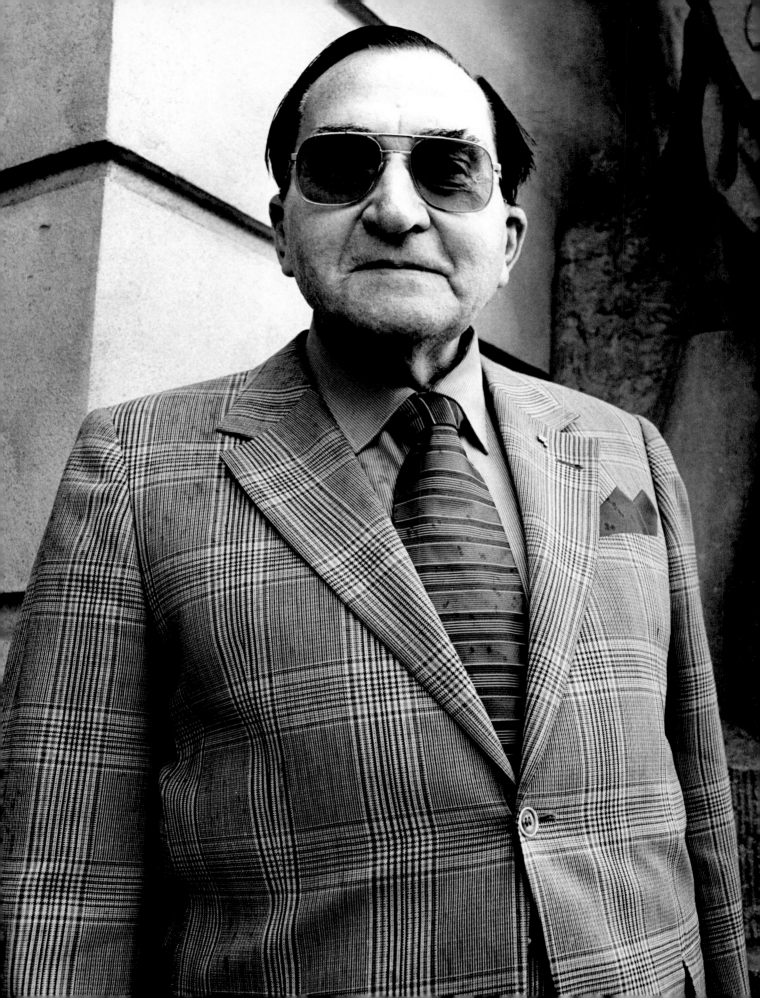

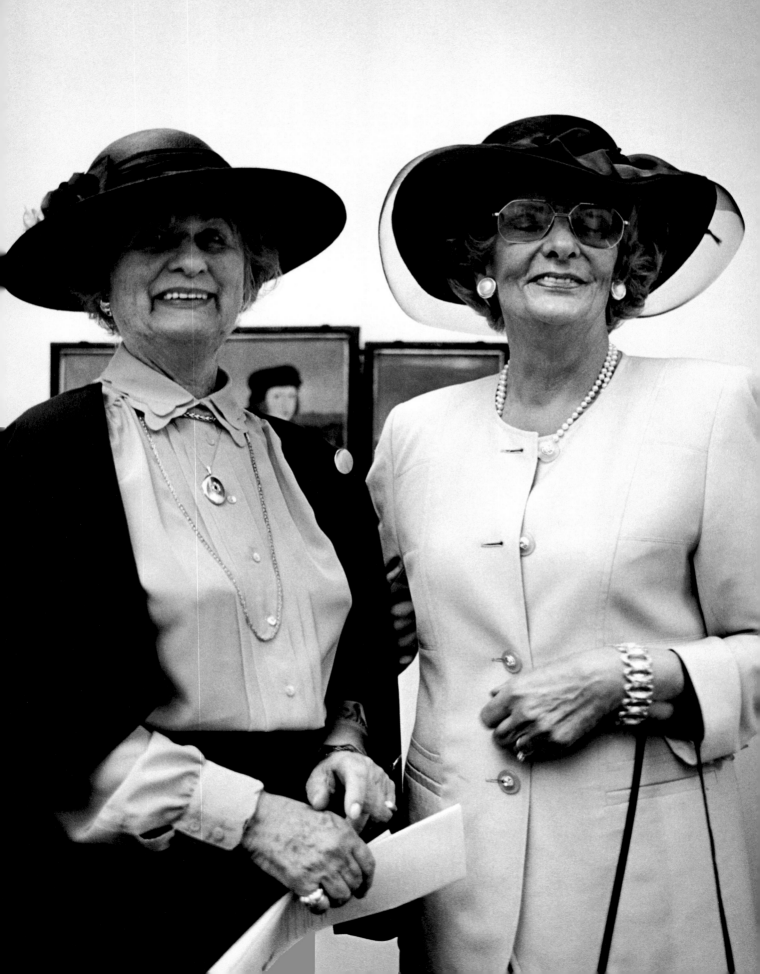

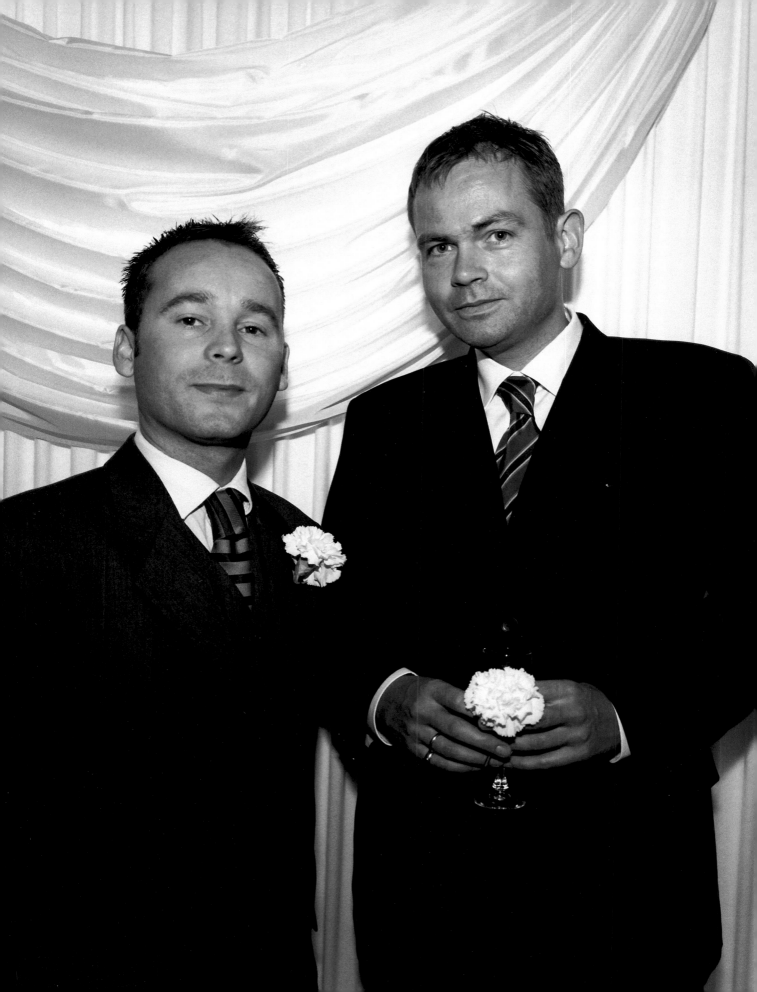

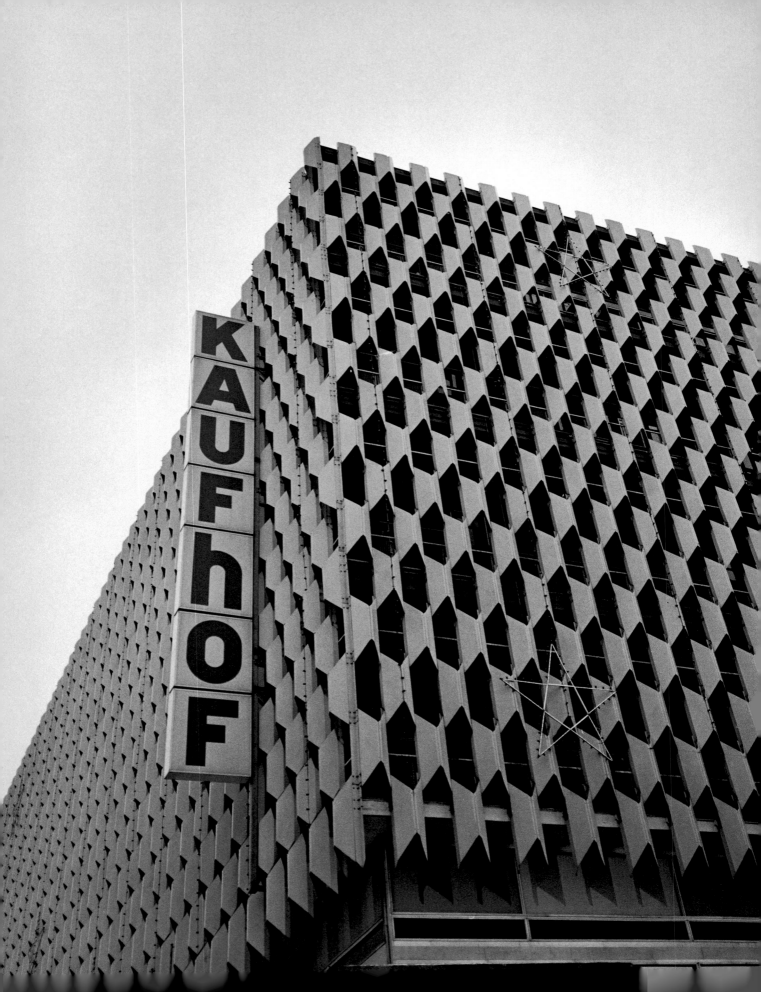

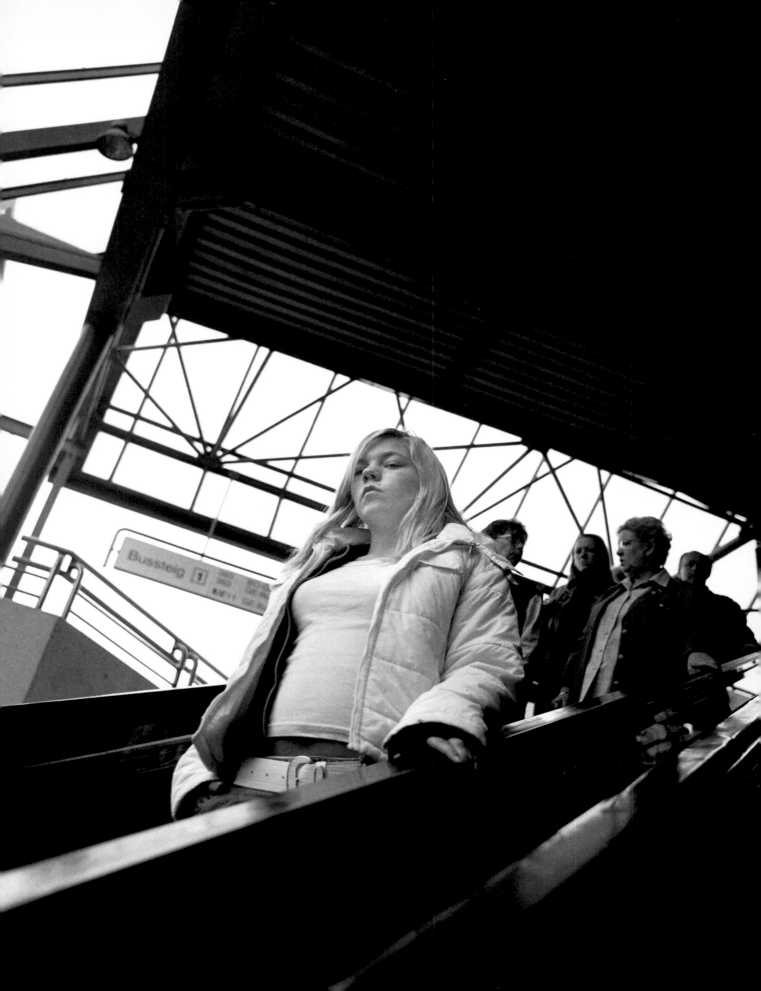

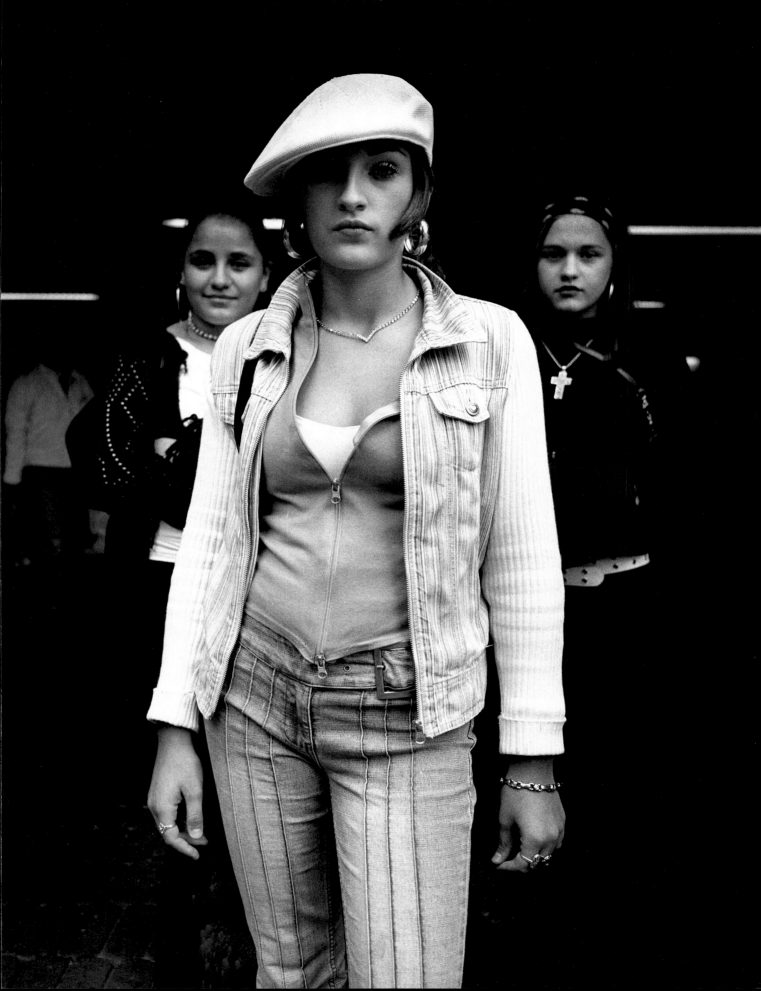

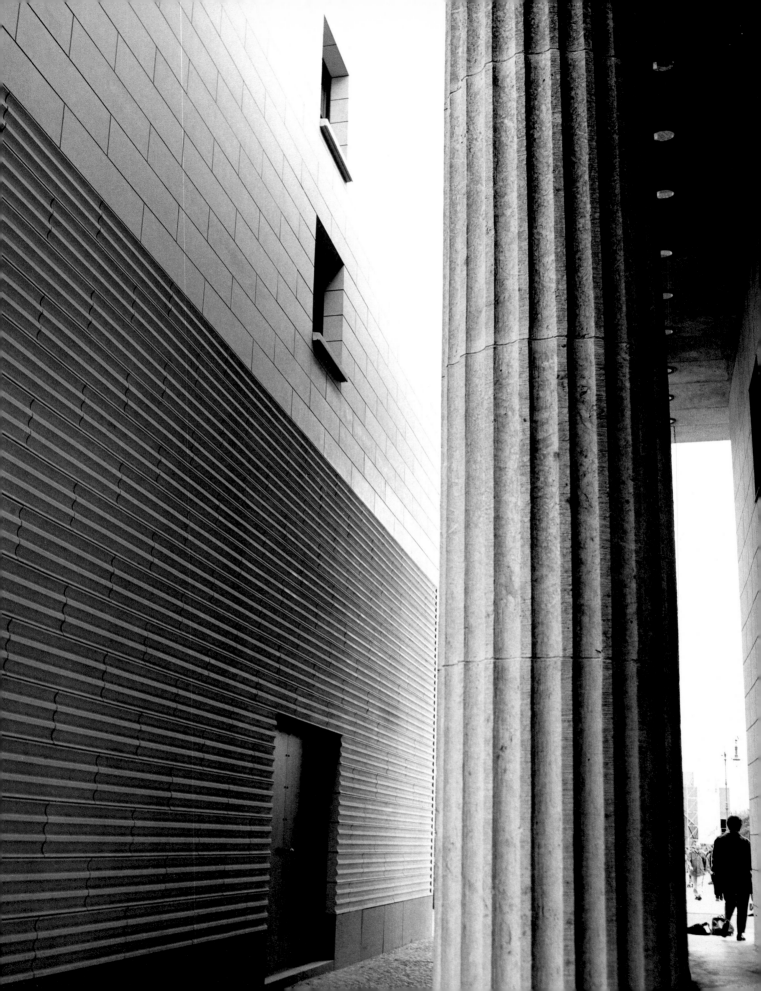

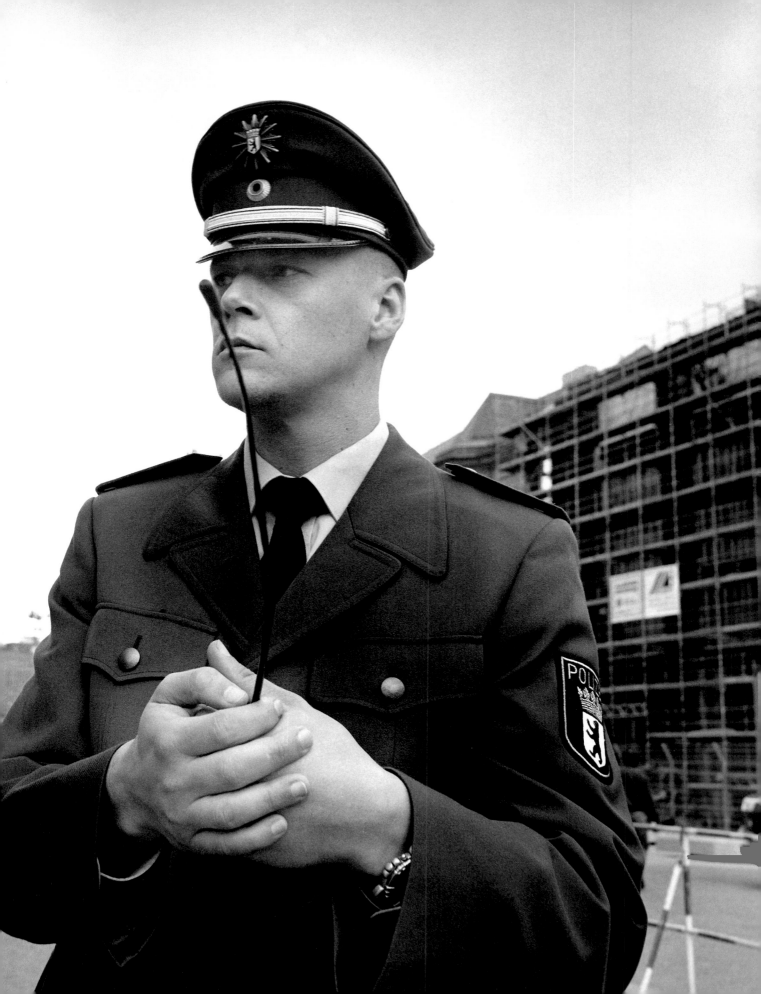

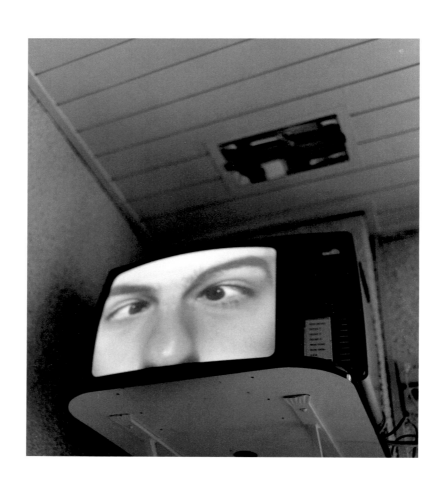

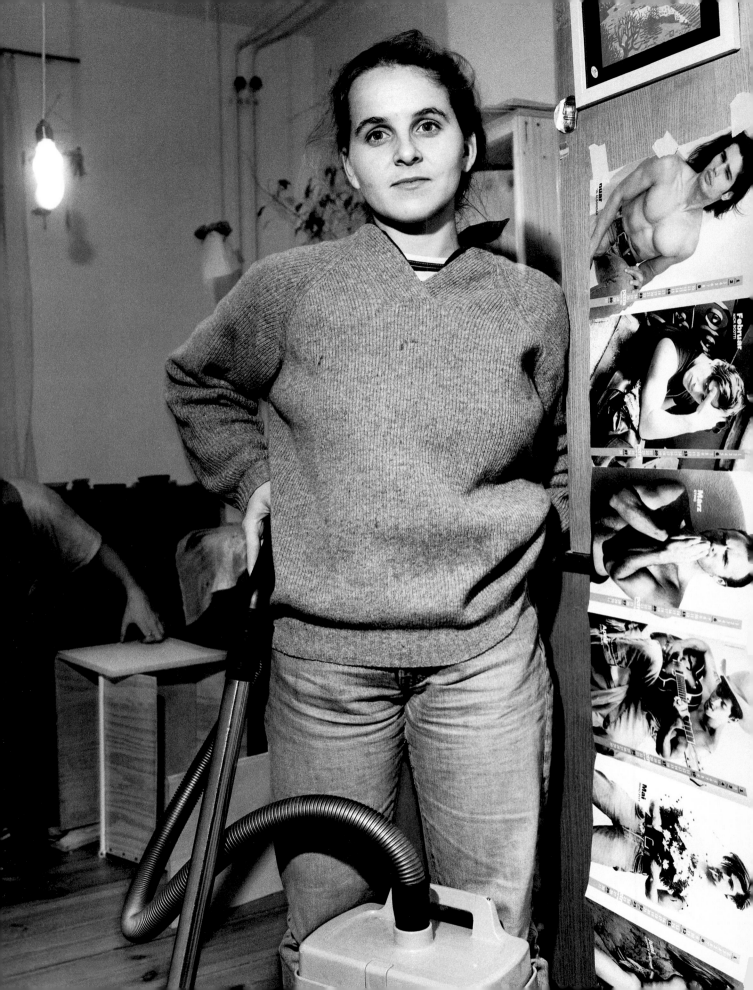

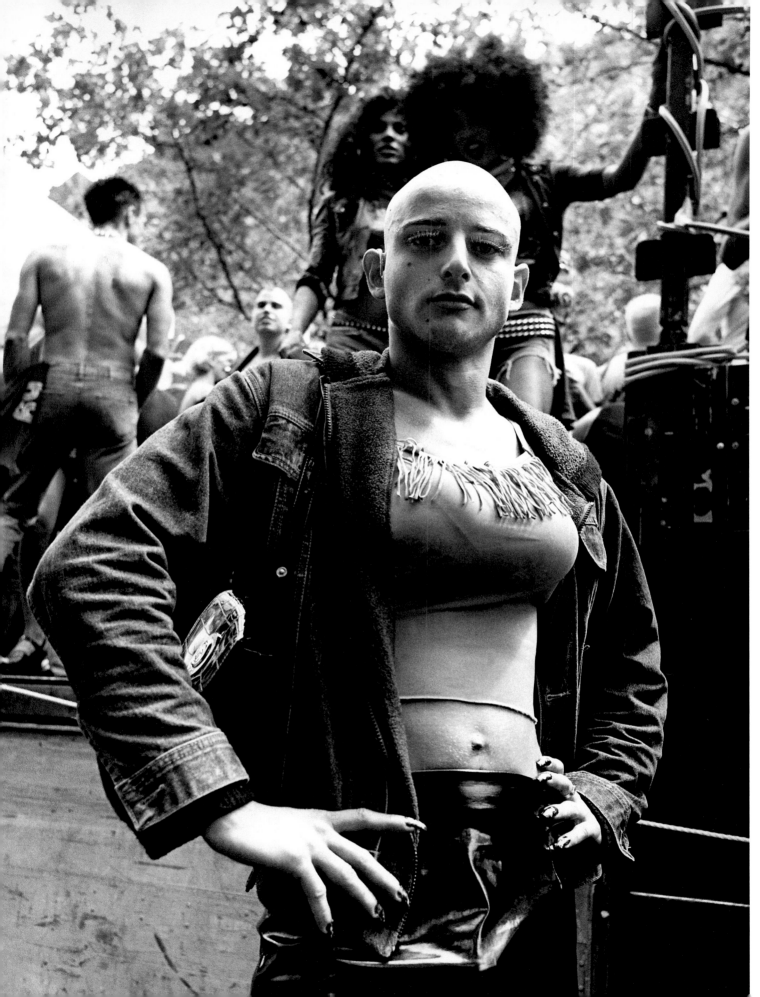

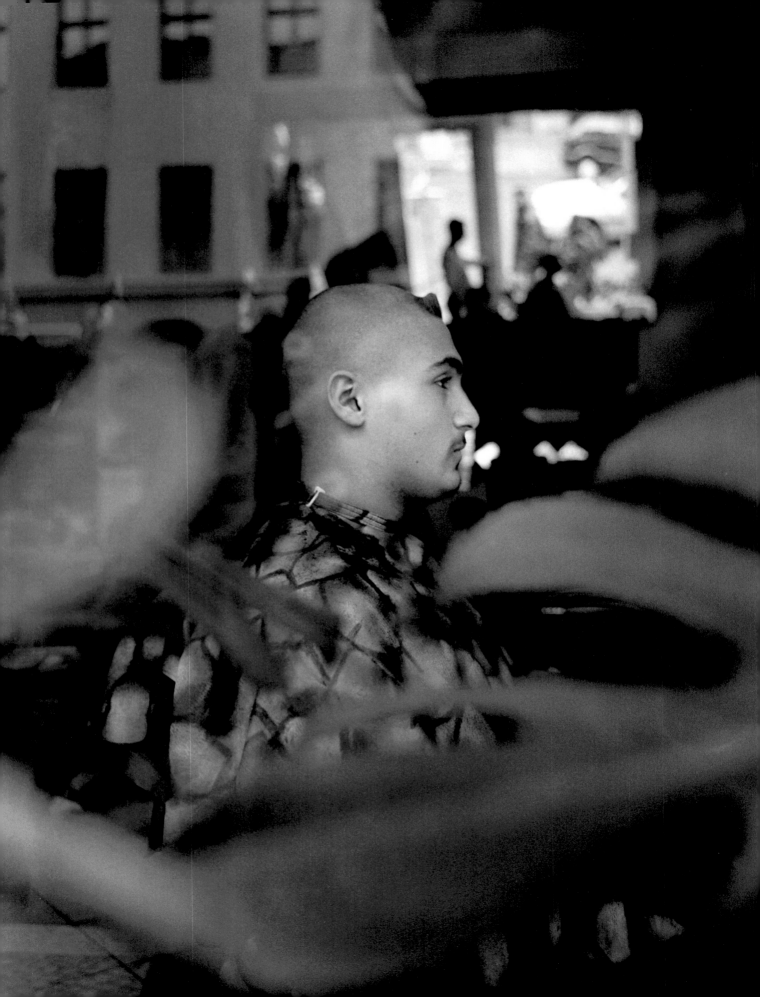

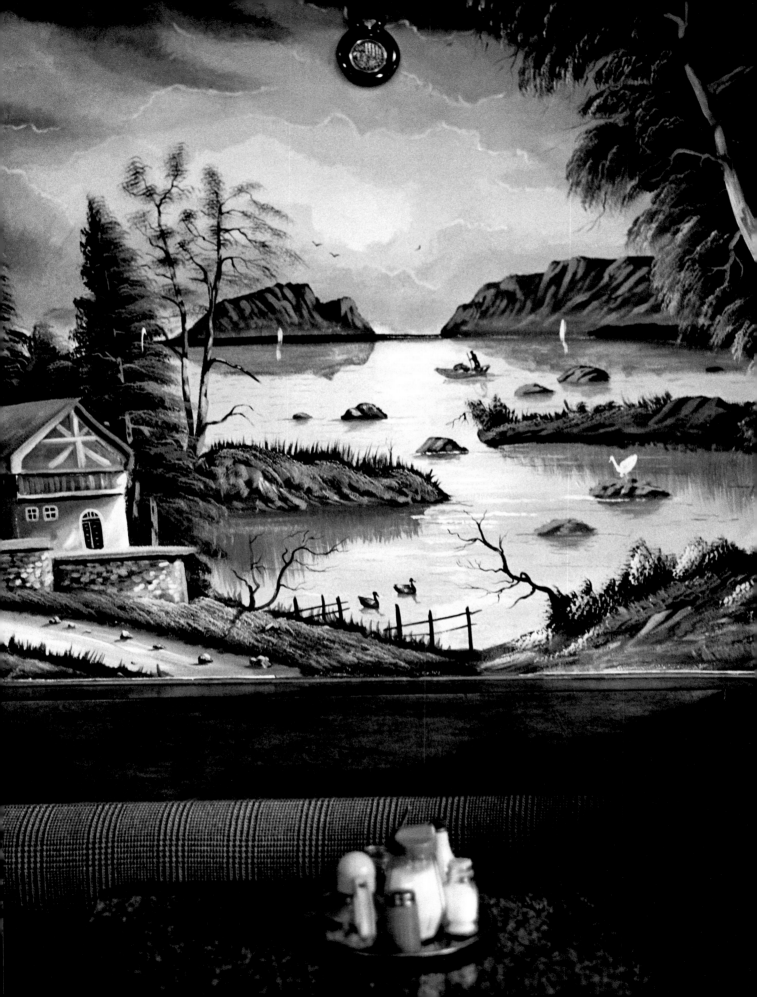

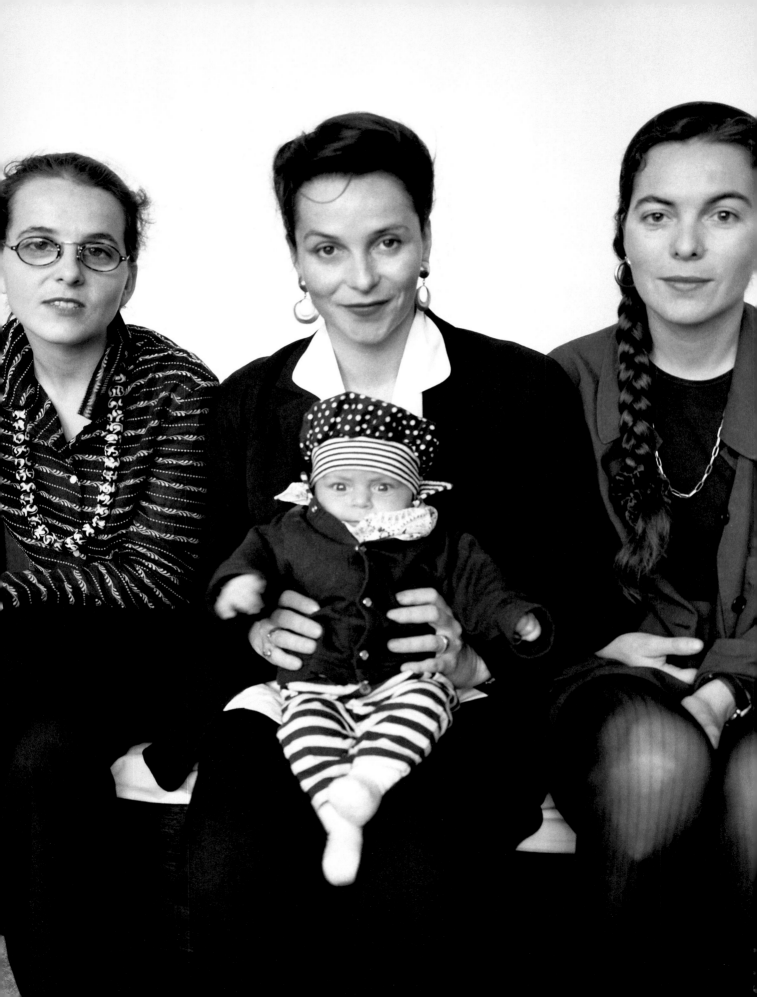

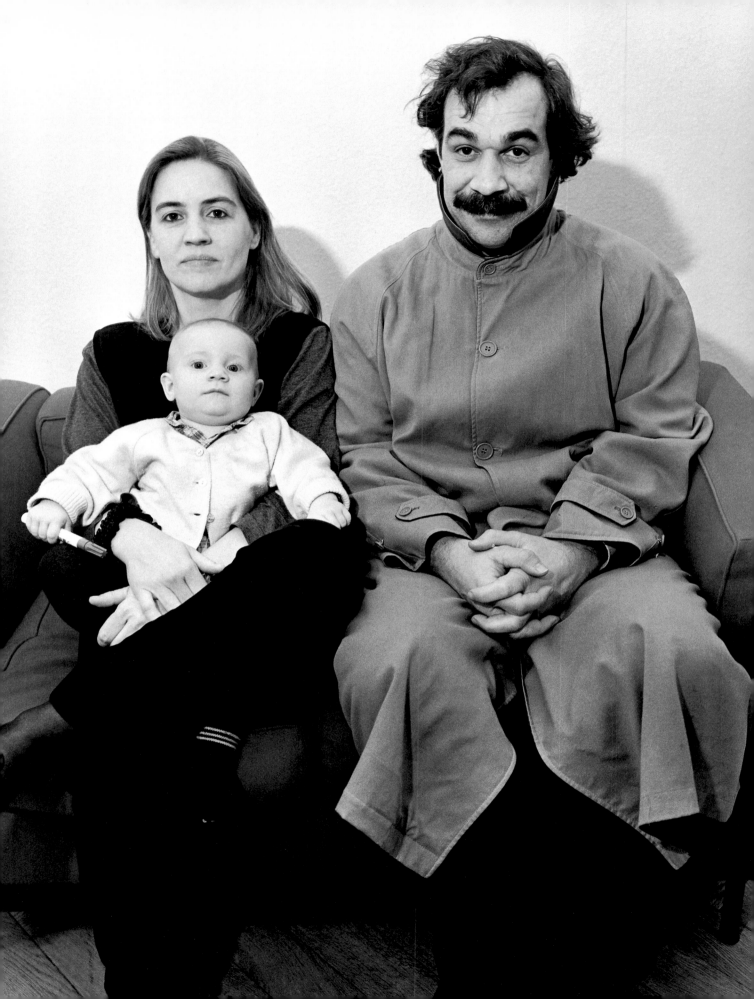

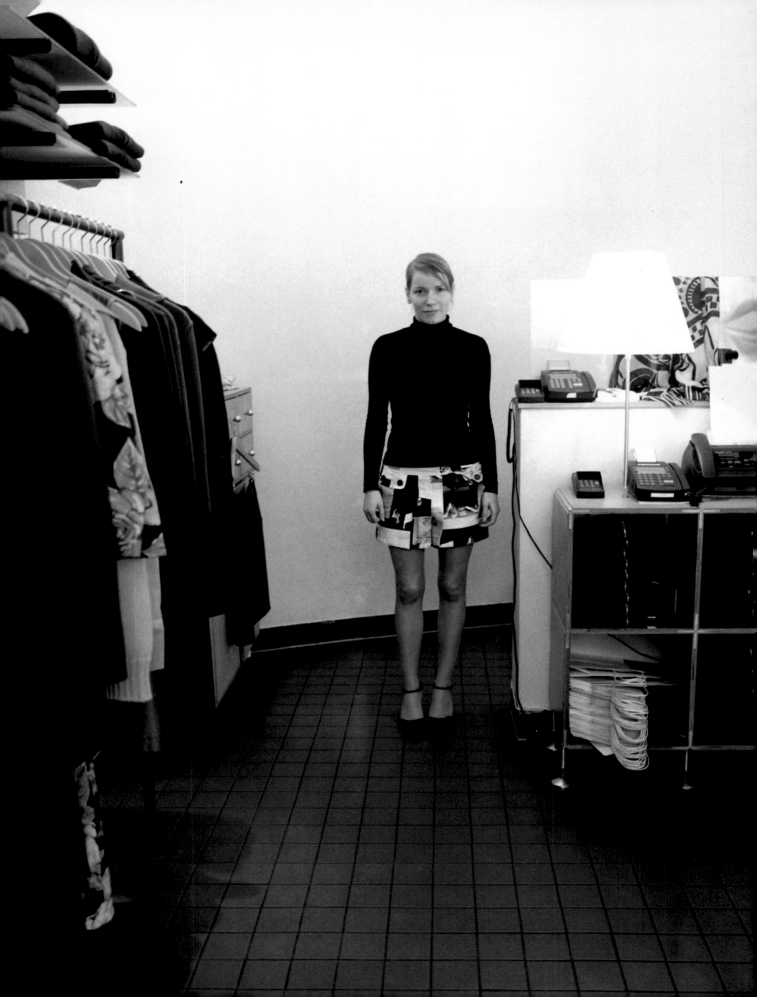

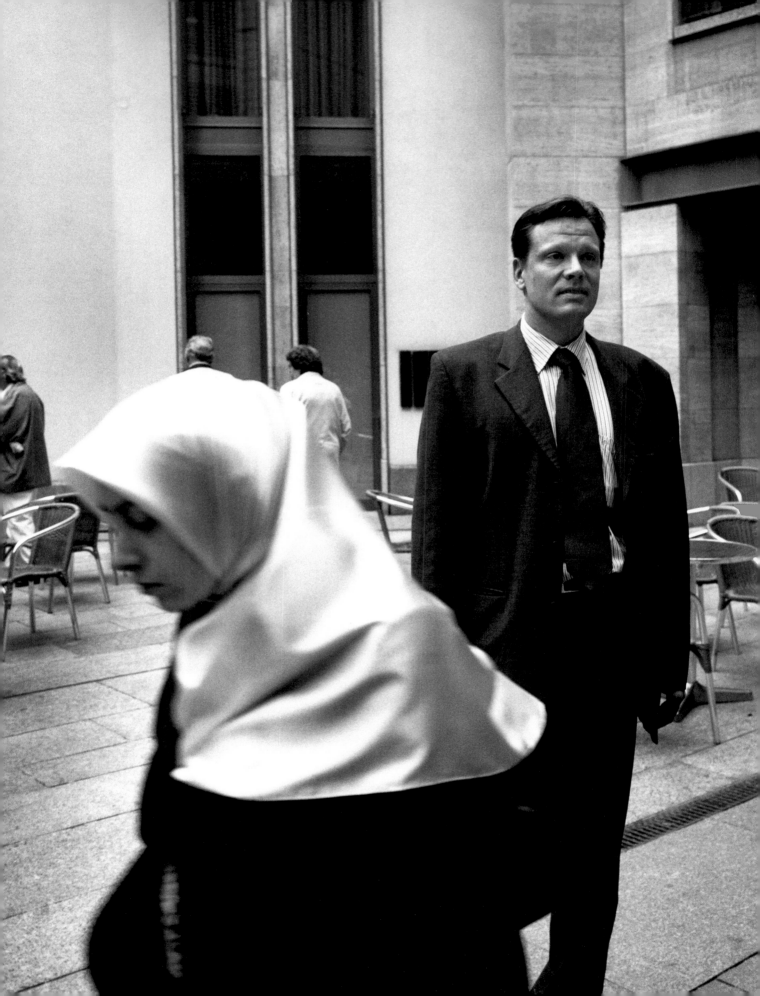

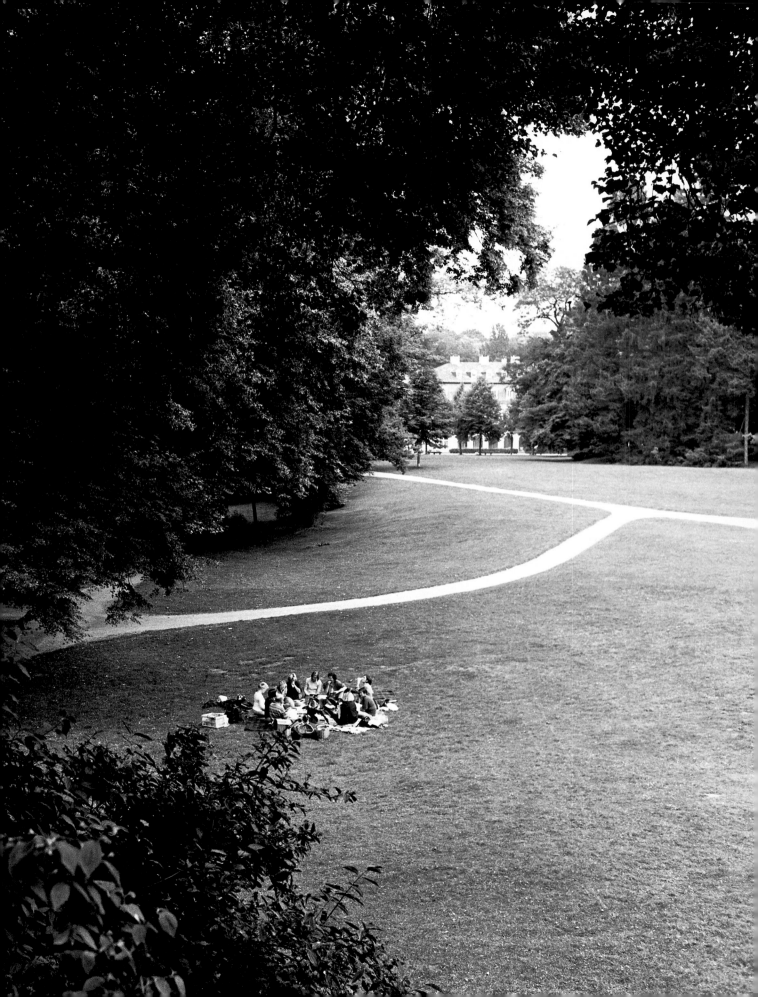

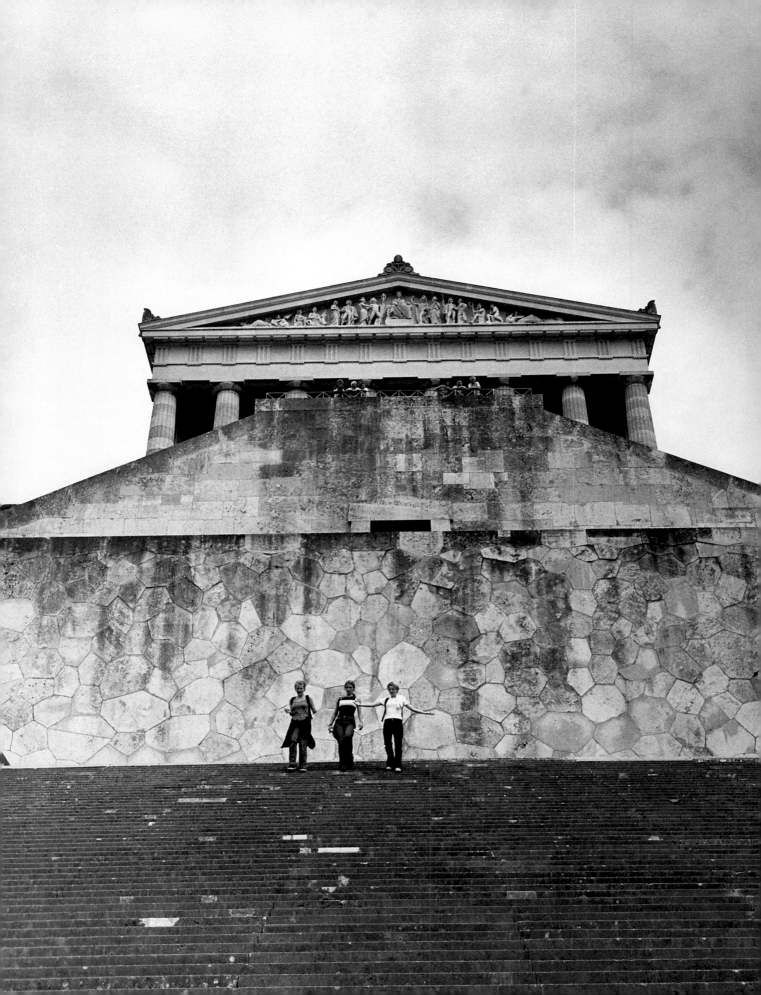

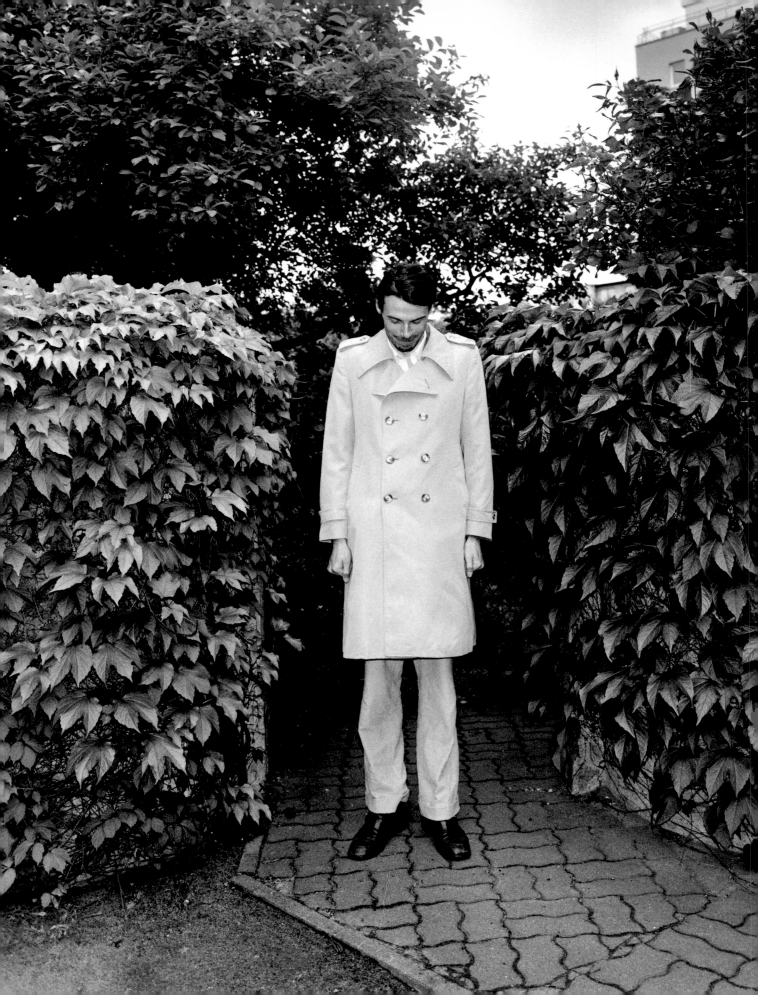

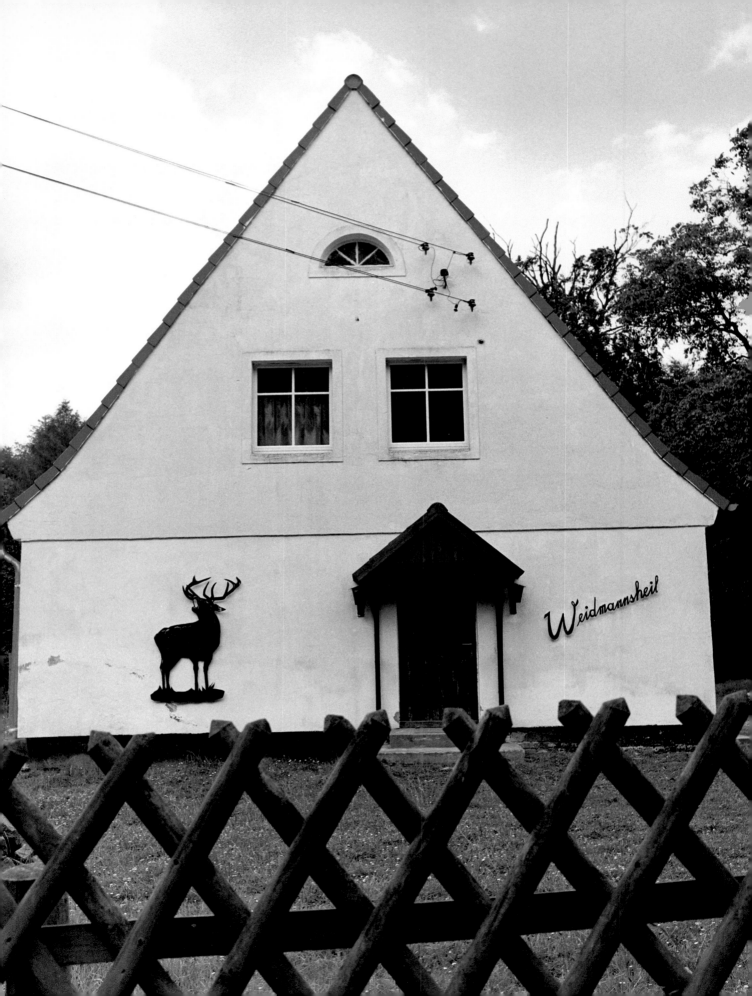

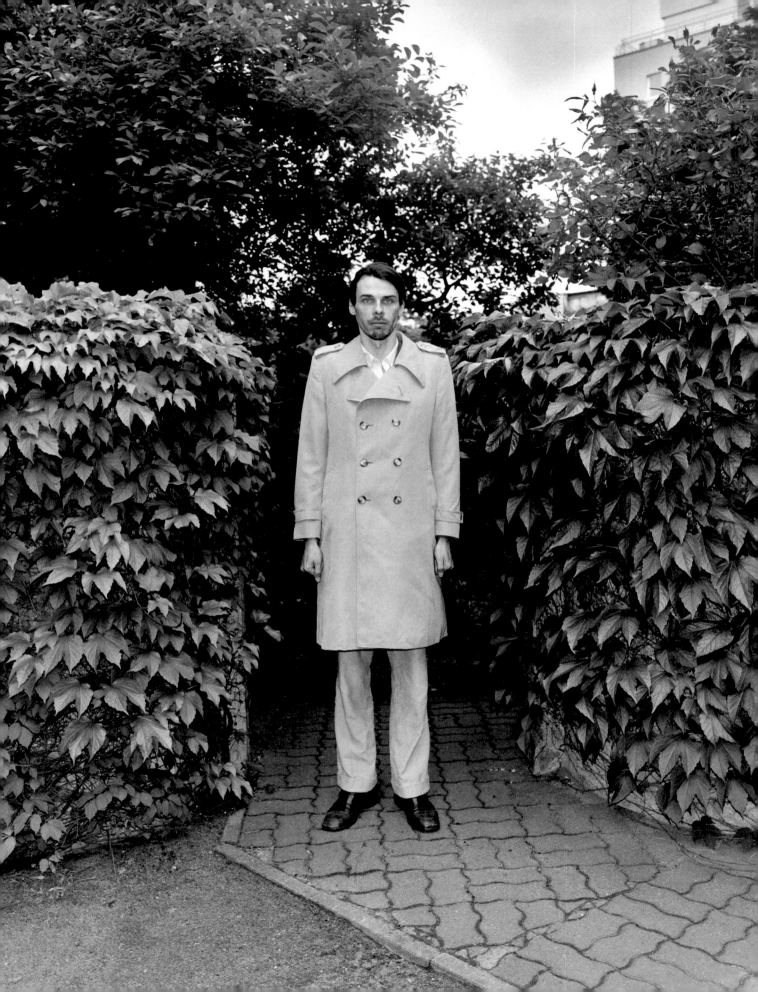

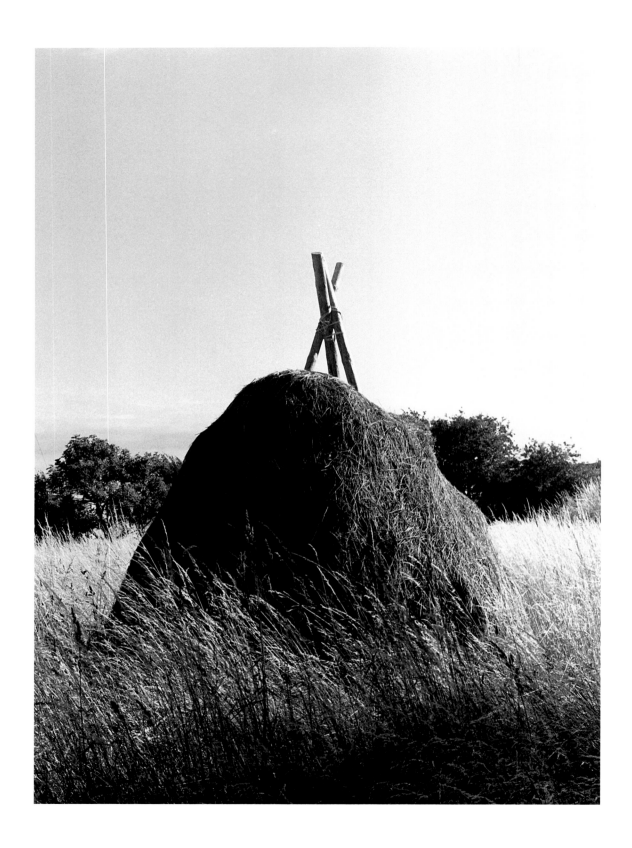

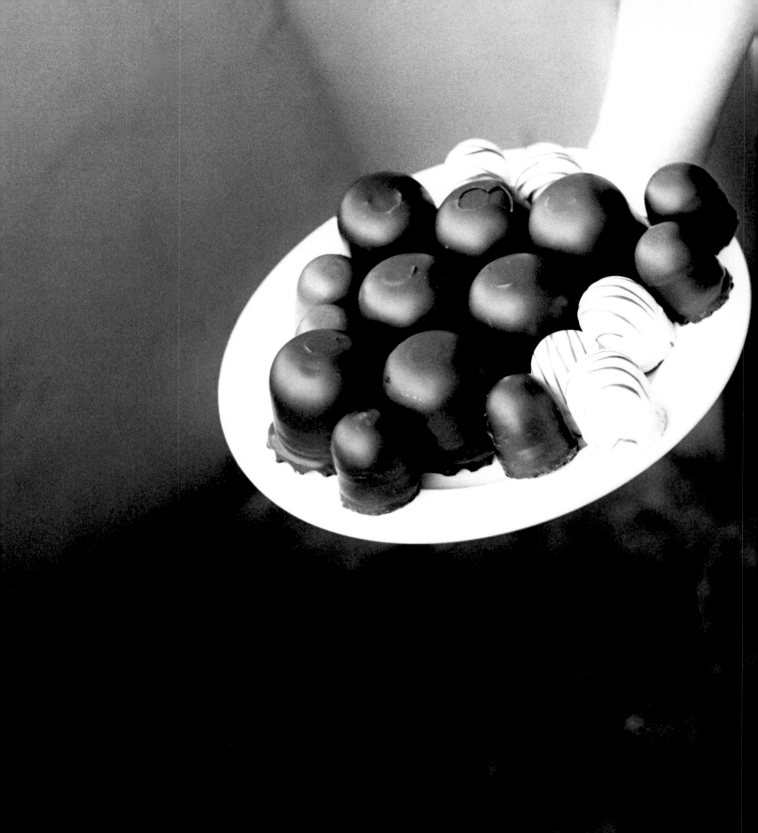

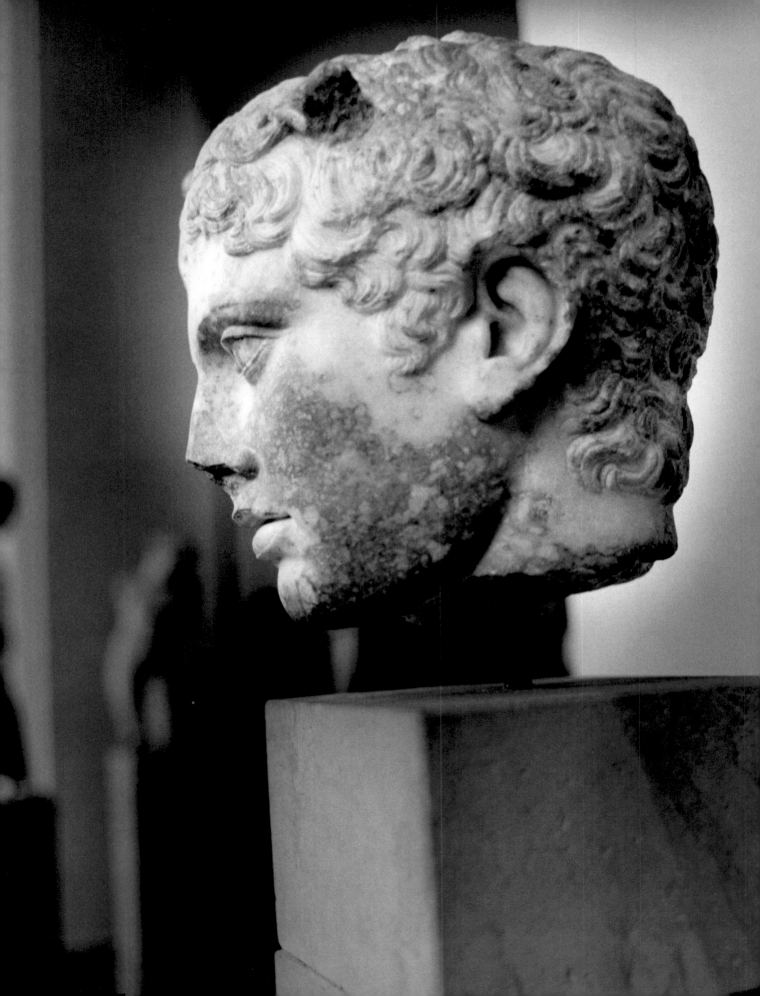

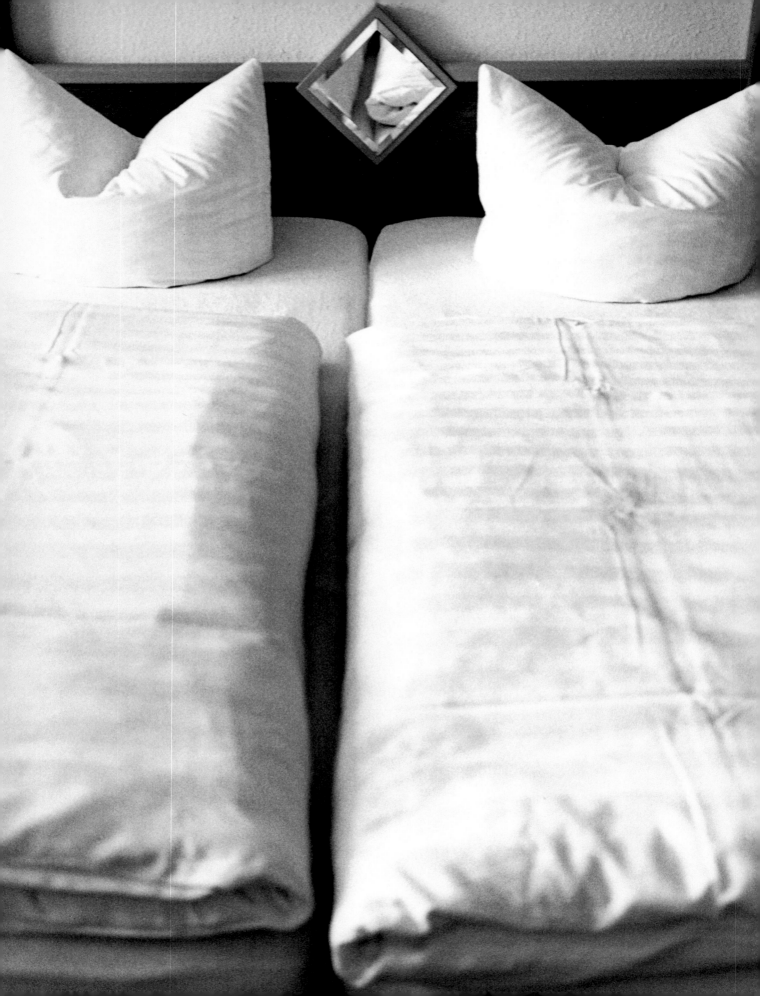

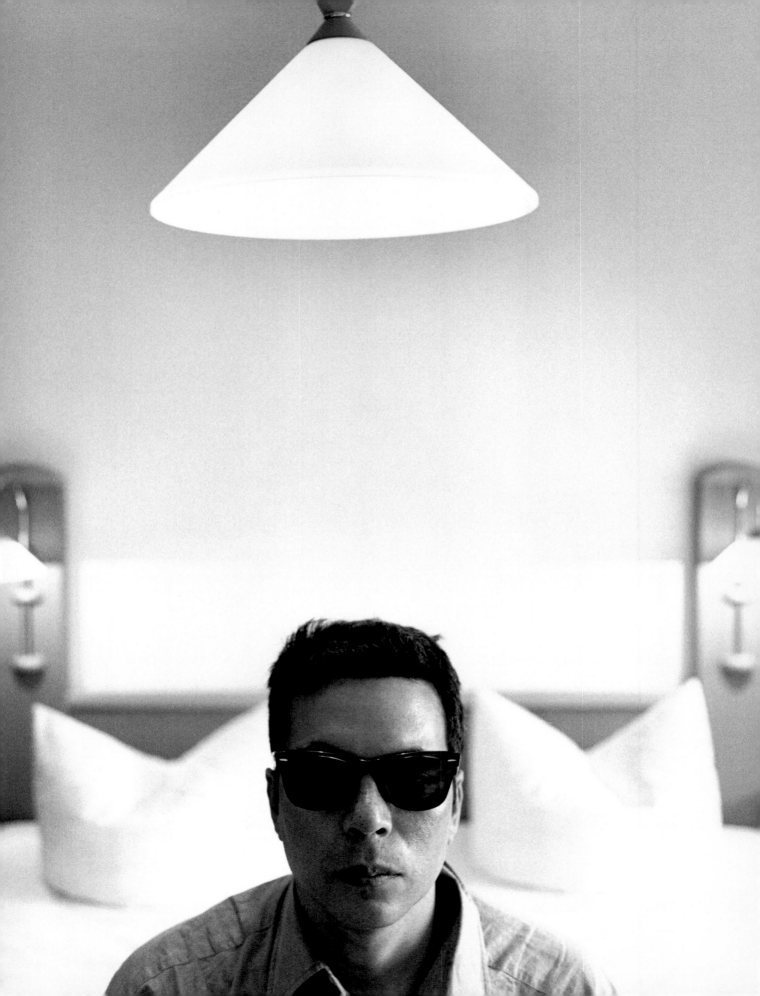

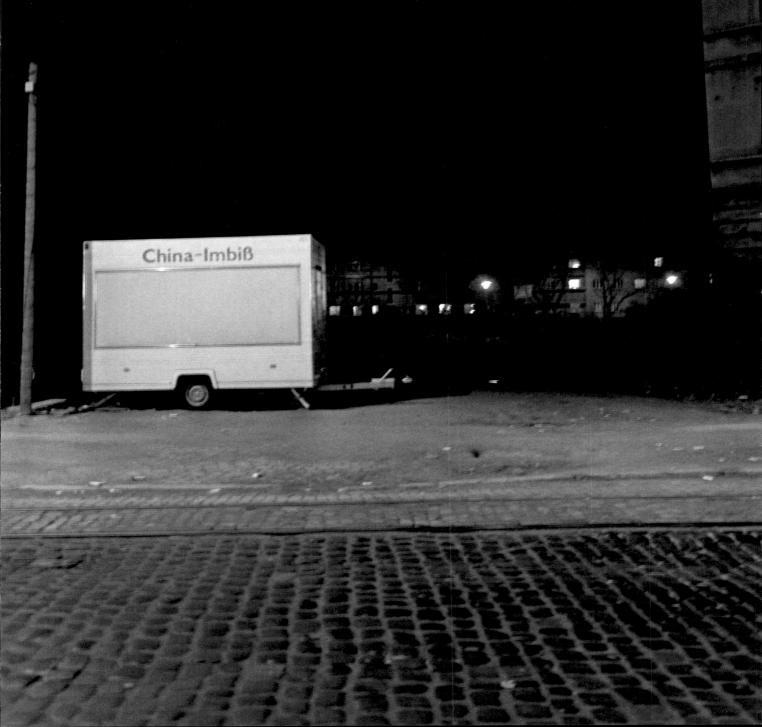

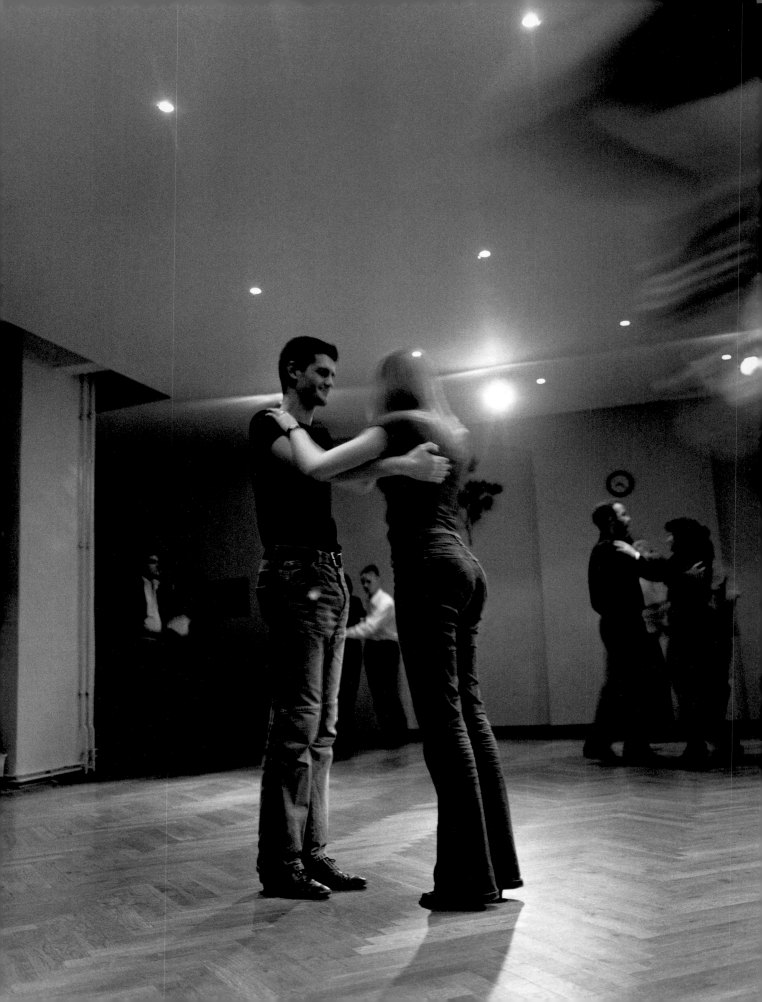

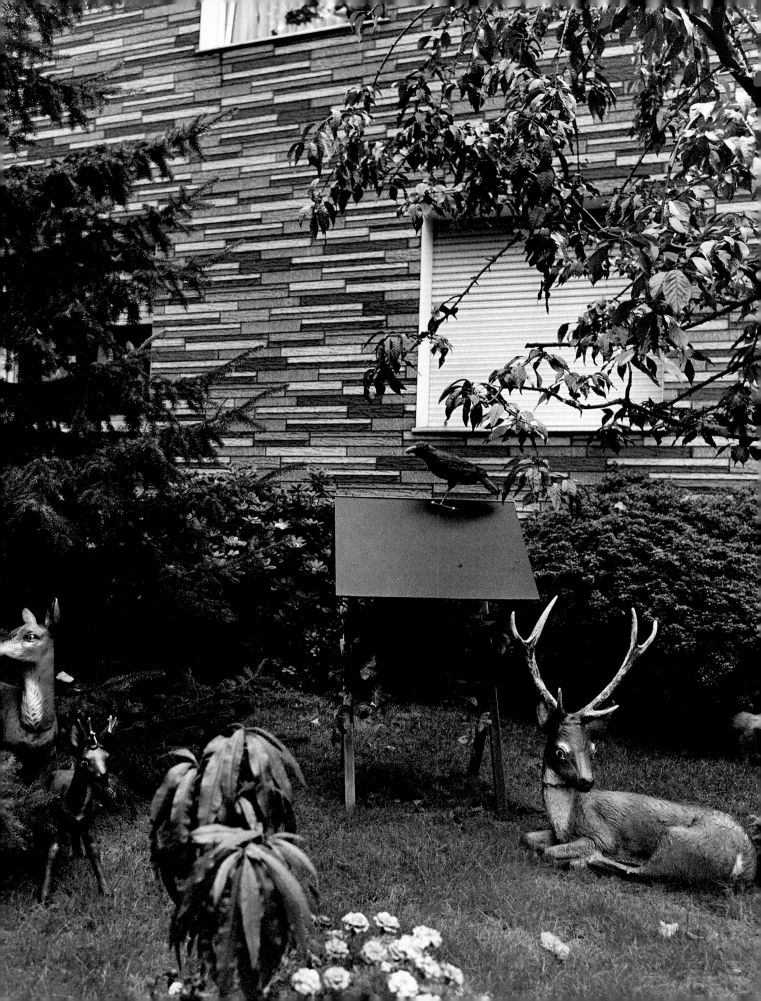

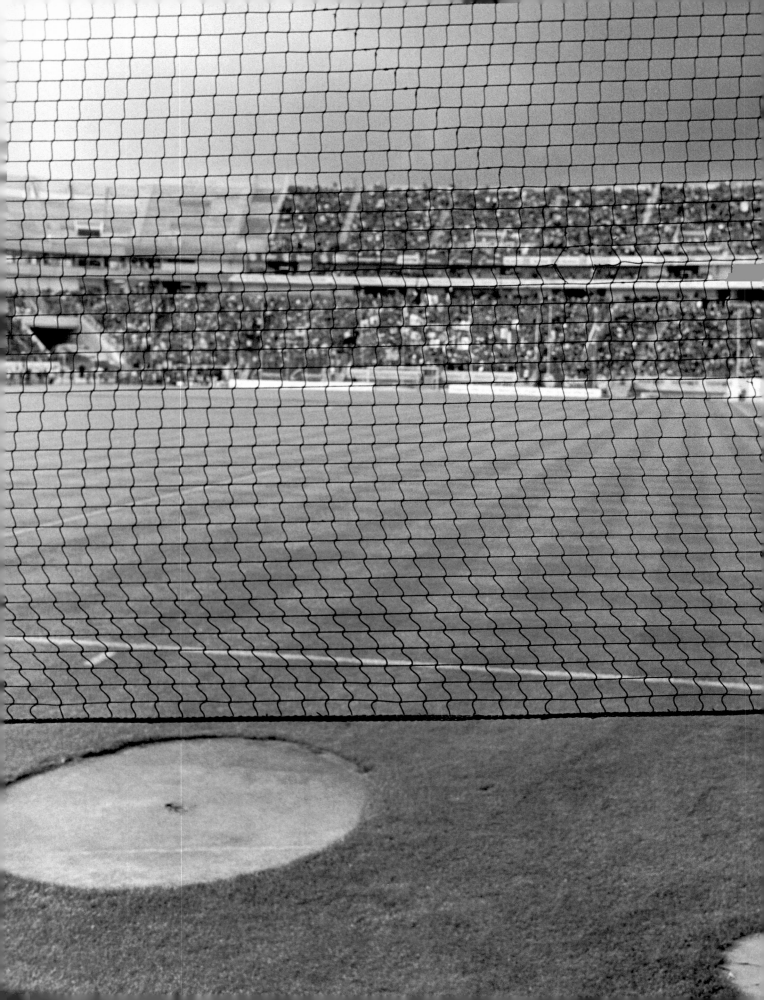

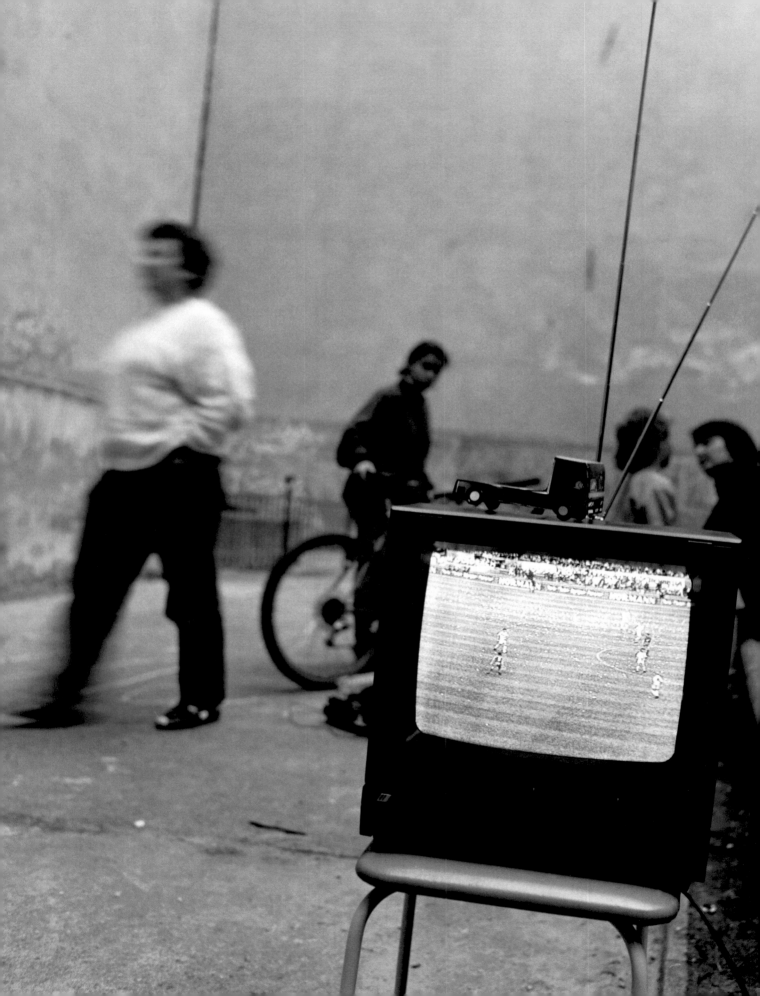

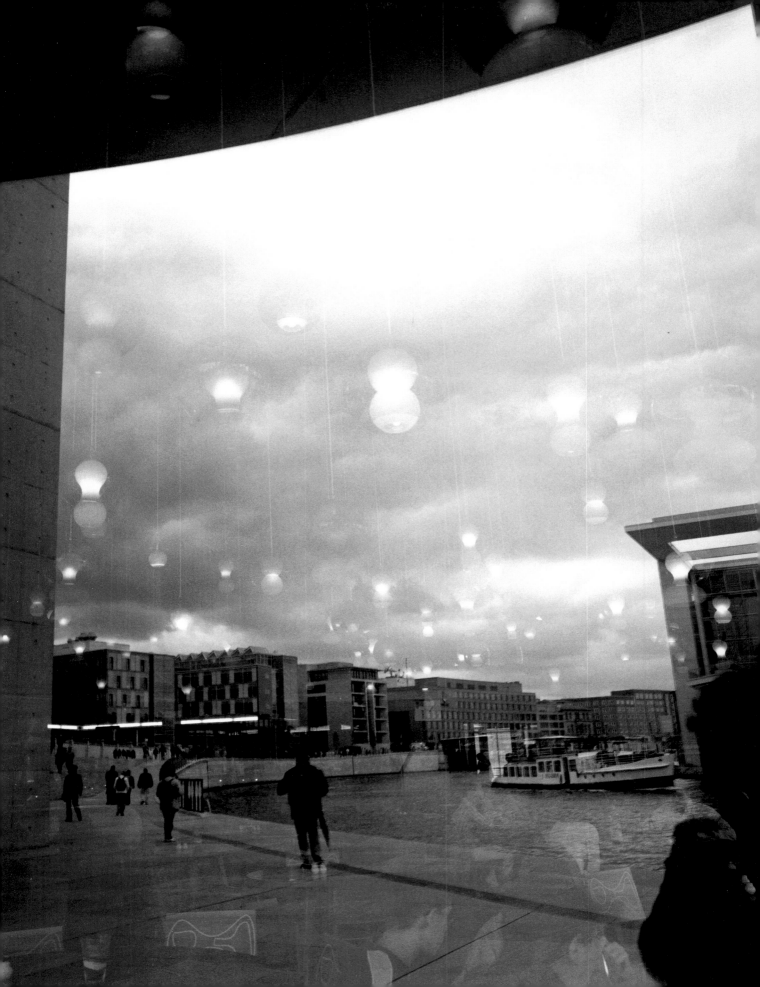

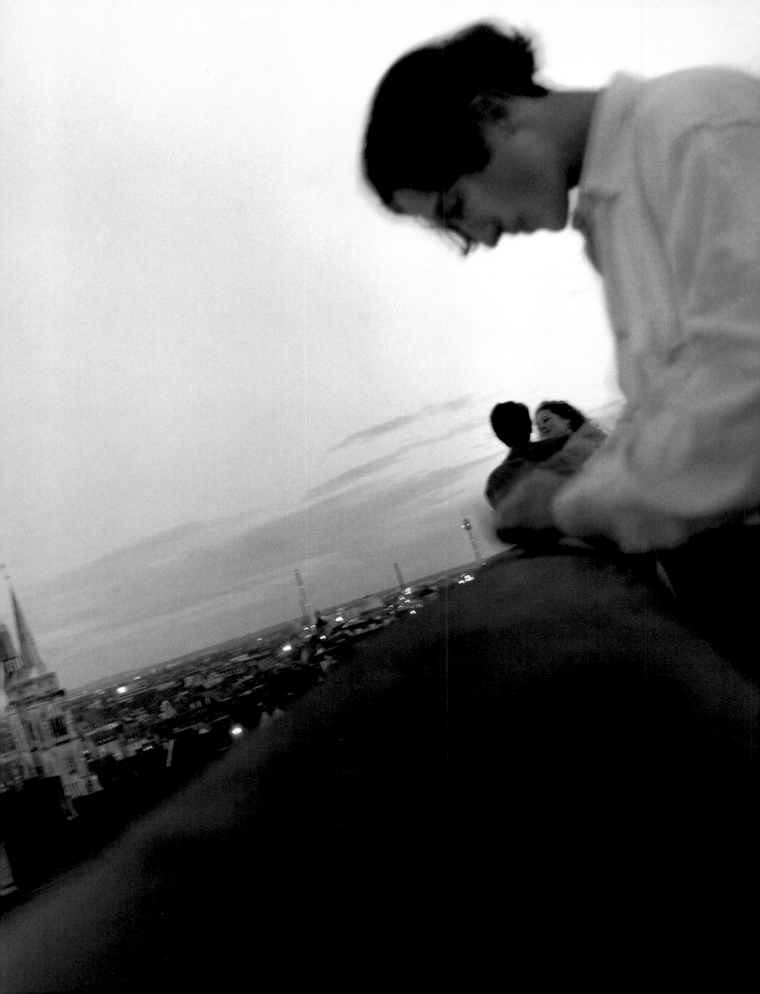

Acknowledgements

This book is to you Philippe, Max and Julian. To the ones who truly make
a house a home, filled with laughter and the beautiful chaos of life.
I thank my family and friends for their support and friendship:
To my mother and Pascale, Florian, Benjamin, Sophie and their families.
To my friends Carolin, Anita, Alessandra, Paul, Peter, Traute, Andrea,
Jordan, Hans-Georg and Bernadette, Sebastian and Ed.

Thanks to Jochen Visscher. Thanks to Orna Frommer-Dawson for your
design. Thanks to Hanns Zischler and Andrian Kreye for your thoughts.

Thanks to Gabriele Betancourt Nuñez, Celine Lunsford, Rainer Danne,
F.C. Gundlach, Susan Kismaric, Elizabeth Biondi, Eliane Laffont,
Kathy Ryan, Scott Thode, Miriam Hsia, Buzz Hartshorn, Anthony
Bannon, Michael and Ann Mehl for their support and encouragement
of this project.

I thank the Amagansett Applied Arts Center and Jenny Gorman for
being my darkroom angel. Thanks to Jane, Julia, and Deena for your
kids expertise and computer and design knowledge.

Danksagung

Dieses Buch ist für Euch, Philippe, Max und Julian, die.Ihr ein Haus
wirklich zu einem Heim macht, erfüllt von Lachen und dem schönen
Chaos des Lebens. Ich danke meiner Familie und meinen Freunden
für ihre Unterstützung und Freundschaft: Meiner Mutter und Pascale,
Florian, Benjamin, Sophie und ihren Familien. Meinen Freunden Carolin,
Anita, Alessandra, Paul, Peter, Traute, Andrea, Jordan, Hans-Georg und
Bernadette, Sebastian und Ed.

Dank an Jochen Visscher. Dank an Orna Frommer-Dawson für Dein
Design. Dank an Hanns Zischler und Andrian Kreye für Eure Gedanken.

Dank an Gabriele Betancourt Nuñez, Celine Lunsford, Rainer Danne,
F.C. Gundlach, Susan Kismaric, Elizabeth Biondi, Eliane Laffont,
Kathy Ryan, Scott Thode, Miriam Hsia, Buzz Hartshorn, Anthony
Bannon, Michael und Ann Mehl für ihre Unterstützung und Ermutigung
zu diesem Projekt.

Ich danke dem Amagansett Applied Arts Center und Jenny Gorman,
meinem Dunkelkammer-Engel. Dank an Jane, Julia und Deena
für Rat und Tat bei der Kinderbetreuung und Eure Computer –
und Designkenntnisse.

Train Trip to
Frankfurt
1995

Zugfahrt nach
Frankfurt
1995

House
Steinheim
1998
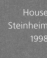

Haus
Steinheim
1998
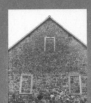

Train Station
Square Nightscape
Osnabruck
1994
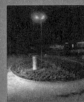

Bahnhofsvorplatz
bei Nacht
Osnabrück
1994

Hotel Beds
Neuschwanstein
1997

Hotelbetten
Neuschwanstein
1997

Family Photographs
St. Martin
1993

Familienphotographien
St. Martin
1993

Living Room
Gronau
1995

Wohnzimmer
Gronau
1995
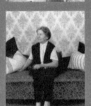

Doll House
Strehlen
2002
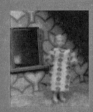

Puppenstube
Strehlen
2002

Dirndl
St. Martin
1994

Dirndl
St. Martin
1994

Crumpled Hotel Pillow
Zurich
1995
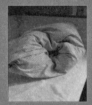

Zerdrücktes Hotelkissen
Zürich
1995

Doll House
Strehlen
2002

Puppenstube
Strehlen
2002

Osnabruck
1995
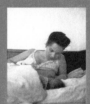

Osnabrück
1995

Strehlen
2001

Strehlen
2001

National Gallery
Berlin
1994

Nationalgalerie
Berlin
1994

Jewish Cemetery
Berlin
1990

Jüdischer Friedhof
Berlin
1990

Door Bell
Berlin
1994

Türklingel
Berlin
1994

Roots
Rugen
1998

Wurzeln
Rügen
1998

Soccer Figures
in Living Room
Berlin
1991

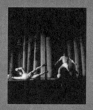

Fußballerfiguren
in Wohnzimmer
Berlin
1991

Stadium at the
former Nazi
Reichsparteitag Area
Nuremberg
1998

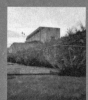

Stadion auf
dem ehemaligen
Reichsparteitagsgelände
Nürnberg
1998

Latin Library
Berlin
1992

Lateinische Bibliothek
Berlin
1992

Concentration Camp
Dachau
1998

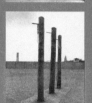

Konzentrationslager
Dachau
1998

Picnic
Frankfurt
1995

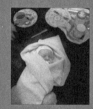

Picknick
Frankfurt
1995

Concentration Camp
Sachsenhausen
1991

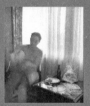

Konzentrationslager
Sachsenhausen
1991

Self Portrait
1995

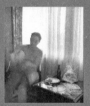

Selbstporträt
1995

Pilgrimage
Altotting
1991

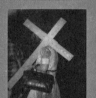

Wallfahrt
Altötting
1991

Self Portrait
1995

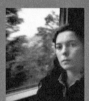

Selbstporträt
1995

Concentration Camp
Sachsenhausen
1991

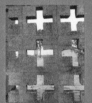

Konzentrationslager
Sachsenhausen
1991

Stuffed Animals
Regeldorf
1995

Ausgestopfte Tiere
Regeldorf
1995

Maximilian Church
Munich
1998

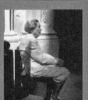

Maximilian-Kirche
München
1998

East German Officer's
Chamber at Prora, what
used to be a Nazi
Vacation Home
Rugen
1998

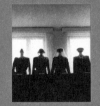

Stube eines
NVA-Offiziers in
Prora, einer ehemaligen
NS-Ferienanlage
Rügen
1998

Chairs at
National Gallery
Dresden
1998

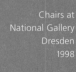

Stühle in der
Nationalgalerie
Dresden
1998

Speer's Studio
Berlin
1999

Speers Studio
Berlin
1999

Files from the
East German Secret
Service ("Stasi")
Berlin
1994

Akten des DDR-
Staatssicherheitsdienstes
Berlin
1994

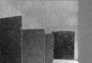

Altötting
1991
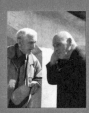

Altötting
1991

Christmas
Crossword Puzzle
Wolfsburg
1998

Weihnachtskreuz-
worträtsel
Wolfsburg
1998

East German Officer's
Room at Prora
Rugen
1998
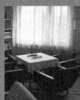

Stube eines NVA-
Offiziers in Prora
Rügen
1998

Women in Subway
Berlin
1994
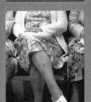

Frauen in U-Bahn
Berlin
1994

Jewish House
Weimar
1998

Jüdisches Haus
Weimar
1998

Man at Swimming Pool
Berlin
1991
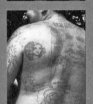

Mann in Schwimmbad
Berlin
1991

Walk along the Wall
Berlin
1991

Gang entlang der Mauer
Berlin
1991

Woman drinking Fanta
Munich
1991

Frau Fanta trinkend
München
1991

Death Strip between
East and West Berlin
during the Fall of
the Wall
1989
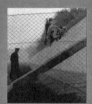

Todesstreifen zwischen
Ost- und West-Berlin
während des Falls
der Mauer
1989

Man looking at
the Rhine
1998
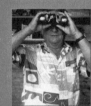

Mann auf den
Rhein schauend
1998

Files of the East
German Secret
Service after the
Reunification
1994

Akten des DDR-
Staatssicherheitsdienstes
nach der
Wiedervereinigung
1994

Swimmer
at Ostsee
1998
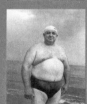

Schwimmer an
der Ostsee
1998

Potatoes
Hildesheim
2000

Kartoffeln
Hildesheim
2000

Telephone Conversation
Munich
1998
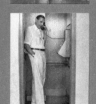

Telephongespräch
München
1998

Soviet Soldier inside
a Russian Military
Compound
Wunsdorf
1998
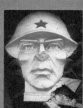

Sowjetsoldat in
einer russischen
Kaserne
Wünsdorf
1998

Ticket Counter
Gelsenkirchen
2003
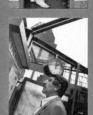

Fahrkartenautomat
Gelsenkirchen
2003

Alexanderplatz
Berlin
2003

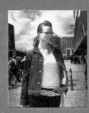

Alexanderplatz
Berlin
2003

Pedestrian Zone
Gelsenkirchen
2003

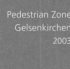

Fußgängerzone
Gelsenkirchen
2003

Pedestrian Zone
Dusseldorf
2003

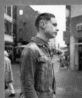

Fußgängerzone
Düsseldorf
2003

Train Station
Dusseldorf
2003

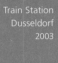

Bahnhof
Düsseldorf
2003

Pedestrian Zone
Gelsenkirchen
2003

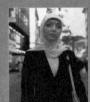

Fußgängerzone
Gelsenkirchen
2003

Brandenburg Gate
Berlin
2000

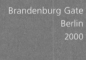

Brandenburger Tor
Berlin
2000

U-Bahn Sign
Berlin
1996

U-Bahn-Zeichen
Berlin
1996

Police Man
Reichstag
Berlin
2000

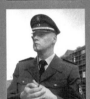

Polizist
Reichstag
Berlin
2000

Berlin
1998

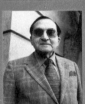

Berlin
1998

TV Program
Zurich
1995

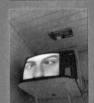

Fernsehprogramm
Zürich
1995

Museum's Opening
Frankfurt
1998

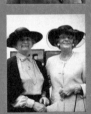

Museumseröffnung
Frankfurt
1998

Berlin
1996

Berlin
1996

Cocktail Party
Osnabruck
1995

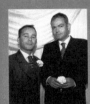

Cocktail-Party
Osnabrück
1995

Love Parade
Berlin
2001

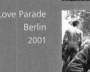

Love Parade
Berlin
2001

Shopping Center
Alexanderplatz
Berlin
1997

Einkaufszentrum
Alexanderplatz
Berlin
1997

Turkish Barber Shop
Frankfurt
2003

Türkischer Friseur
Frankfurt
2003

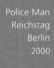
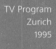

Restaurant Interior
Berlin
2003

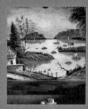

Restaurantinterieur
Berlin
2003

Weidmannsheil
Worpswede
1998

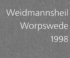

Weidmannsheil
Worpswede
1998

Three Sisters
with Baby
Osnabruck
1995

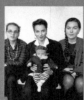

Drei Schwestern
mit Baby
Osnabrück
1995

Berlin
2004

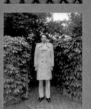

Berlin
2004

Family Portrait
Frankfurt
1995

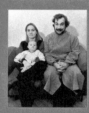

Familienporträt
Frankfurt
1995

Hay Bale
Strehlen
1998

Heuballen
Strehlen
1998

Clothing Store
Berlin
2003

Bekleidungsgeschäft
Berlin
2003

Russian Military
Building
Wunsdorf
1998

Russisches
Militärgebäude
Wünsdorf
1998

Pedestrian Zone
Potsdamer Platz
Berlin
2003

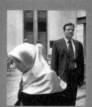

Fußgängerzone
Potsdamer Platz
Berlin
2003

German Candy
Berlin
1998

Deutsche Süßigkeiten
Berlin
1998

Picnic
Herrenhausen
1998

Picknick
Herrenhausen
1998

Roman Bust
Pergamon Museum
Berlin
1996

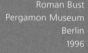

Römische Büste
Pergamon-Museum
Berlin
1996

Walhalla
near Regensburg
1998

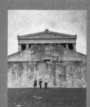

Walhalla
bei Regensburg
1998

Karate Pillows
Rugen
1998

Karatekissen
Rügen
1998

Berlin
2004

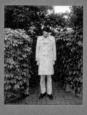

Berlin
2004

Philippe in Rugen
1998

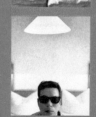

Philippe auf Rügen
1998

Chinese Food Stand
Naumburg
1998

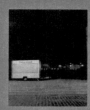

Chinesischer Imbiss
Naumburg
1998

TV Soccer Game
Berlin
1995

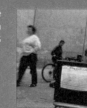

Fußballspiel
im Fernsehen
Berlin
1995

Dancing Lesson
Berlin
2003

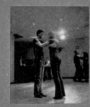

Tanzstunde
Berlin
2003

Berlin
2004

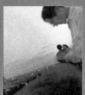

Berlin
2004

Garden Landscape
Recklinghausen
2003

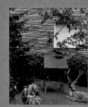

Gartenlandschaft
Recklinghausen
2003

View of Nuremberg
1998

Blick auf Nürnberg
1998

Soccer Match
Frankfurt
2003

Fußballspiel
Frankfurt
2003